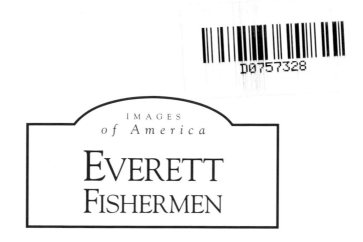

IMAGES
of America

EVERETT
FISHERMEN

Barbara Martinis Piercey took this picture in 1949 with a Ciro-Flex camera she received as a high school graduation gift from her parents. Barbara's cousin Paul Martinis (son of Seaside Paul Martinis) helps unload the nets from the *Freeland*. From left to right are Lloyd Judy, unidentified, Paul Martinis, and unidentified. (Courtesy Barbara Martinis Piercey.)

ON THE COVER: Matt Marincovich (right) attends to the maintenance of a skiff. As one of Everett's prominent commercial fisherman, Matt traveled well over 165,000 miles through the stormy waters of the Gulf of Alaska and the Bering Sea. His seiner, the *Wonderland*, was a well-respected vessel of the Everett fishing fleet. (Courtesy Katy Brekke.)

IMAGES
of America

EVERETT
FISHERMEN

RaeJean Hasenoehrl and the
Everett Fisherman's Tribute Committee

ARCADIA
PUBLISHING

Published by Arcadia Publishing
Charleston SC, Chicago IL, Portsmouth NH, San Francisco CA

Printed in the United States of America

Library of Congress Catalog Card Number: 2007943433

For all general information contact Arcadia Publishing at:
Telephone 843-853-2070
Fax 843-853-0044
E-mail sales@arcadiapublishing.com
For customer service and orders:
Toll-Free 1-888-313-2665

Visit us on the Internet at www.arcadiapublishing.com

To the proud fishermen and their families:
May we remember and honor the past
as we move bravely into the future.

CONTENTS

ACKNOWLEDGMENTS

On behalf of the Everett Fisherman's Tribute Committee, thank you to all who have entrusted us with priceless photograph collections and historical information. Thank you for giving us the opportunity to preserve a small portion of Everett's rich fishing heritage.

The building blocks leading to this book included meetings with Everett Port commissioners Don Hopkins, Phil Bannon, and Jim Shaffer, who unanimously approved our plan to build a monument honoring Everett's fishermen. The following community leaders continue to support this effort: John Martinis Sr., Roland Hublou, Jim Leese Sr., Augie Mardesich, Paul Martinis, Butch Barcott, Ken Olson, Ron Rochon, John Mohr, and Mary Seivers. The Greater Everett Community Foundation and Mike Benbow of the *Daily Herald* have also been very supportive of this project.

Bernie Webber was most generous in donating his watercolor, which was made into 200 prints. Jerry Barhanovich also provided artistic talents, designing and stitching the logo for collectible hats. Both items are currently being sold in a fund-raising effort.

Marci Dehm was instrumental in introducing me to the Fisherman's Tribute Committee. Editor Julie Albright's encouragement and sense of humor made preparing this book a pleasure.

Margaret Riddle and the Everett Public Library again offered a helpful hand in producing an Arcadia publication. The library's Northwest Room is a treasure trove of wonderful images and historical text.

Fundamental to our pictorial history is the work of photographer Melissa Holzinger. Melissa scanned and repaired nearly 300 pictures. Lloyd Weller, head of photography, and the staff of Everett Community College enabled Melissa to finish this project with great professionalism.

Our deepest thanks go to our husbands and families who lent wholehearted support. We are grateful for your understanding of long hours spent away from home, your willingness to live with stacks of information and photographs, your suggestions, and your proofreading skills.

Finally, the keystone of the entire project is the four-person committee of Kay Zuanich, Barbara Piercey, Cheryl Ann Healey, and Katy Brekke. This group of ladies, with the same indomitable spirit as their Croatian ancestors, took on this project with grace, organization, and enthusiasm.

—Respectfully submitted by RaeJean Hasenoehrl

INTRODUCTION

During the 1890s, the first Croatian and Scandinavian families ventured to Everett, Washington, in search of a new life and a maritime destiny. The men brought with them the skills of their native country. Both groups were proficient fishermen, casting wide nets to gather in schools of fish. Purse seiners, gillnetters, and bottomfish trawlers dotted the tidal waters, contributing to the success of the newly formed fishing community.

Newcomers encouraged others from their native countries to also immigrate to America. As money was earned in Everett, family members were brought from their homeland to their new land on the coast of Puget Sound. A commercial fleet was born, and an entire country (and later, the world) soon enjoyed the bounty of the Puget Sound and the coastal waters off Alaska, Oregon, and Washington.

The Croatians, joined by their Scandinavian counterparts, faced both triumph and strife as they worked to make the Port of Everett one of the busiest ports in the country. Their steel-minded heritage prepared them for long days at sea, the solitude of the hunt, and the wrath of the storm. In turn, the spoils of months at sea sustained their growing community and brought about the success of trade across the country.

Family members who remained on land experienced the lonely distance from husbands, fathers, and brothers with courage and fortitude. Many worked for businesses directly involved with the fishing industry. Often, young girls and women worked long days at the local processing plants, standing in water while washing and cleaning the fish. Local industries, such as grocers, meat markets, hardware stores, and fueling stations, provided wares that sustained the maritime core.

Through the years, several events have marked the history of Everett's fishing industry, including salmon treaties with Canada, the Boldt decision of 1974 (that granted Washington tribes 50 percent of the catch in historic fishing areas), and tense moments watching Russian fishermen enter the waters of the Pacific. Ships capsized, lives were lost, and families mourned. But the prevailing sense of duty to family and heritage stood at the forefront, spurring on the triumph of hard work and determination.

Today this fishing fleet has dwindled to just a few boats. Symptoms of its demise include high expenses, diminishing fish runs, the introduction of farmed salmon, and a lack of local fish processors. Another fatal blow to the industry is on the horizon: the net sheds that provide work space for the fishermen will be razed and a $400 million development will instead flank the waters of Puget Sound.

Members of Everett fishing families, looking to preserve their long maritime history, developed the Everett Fisherman's Tribute Committee. This book, which will raise funds for a monument honoring the fishermen, explores the depths of Everett's fishing industry, its families, and its culture. At present, there is little written or archived about this community's fishing industry and its contribution to Everett's ethnic culture, church community, and leadership core. This book is a small gesture to bring those memories to life. In bringing the events of the past to life, we grant a bounteous gift of knowledge and heritage to present and future generations.

—RaeJean Hasenoehrl, author

"With the challenges I have faced and overcome in fishing, I can see why my ancestors would be able to face the challenge of leaving their homeland for a better life. That's basically what fishing is: we leave home to face the uncertain and deal with whatever comes up in our effort to provide a better life. Fishing is a tough life. Lives lost, families broken. I've heard fishing described as 'months of boredom punctuated by moments of sheer terror.' It is the adrenaline—intoxicating, addicting adrenaline that keeps us coming back. It is hard to imagine the rush of being out on the ocean in weather that creates an environment trying to rip us apart. . . . Knowing, feeling, and sometimes even seeing so much fish that if we are able to pull it off, beat the odds and get those fish aboard, our family and the families of our crew would be set for months.

"We know we have to do it.
We take the chance.
We yell to the crew, 'Let it go!'"

—Written by Paul Piercey, grandson of Winnie and Tony Martinis Sr.

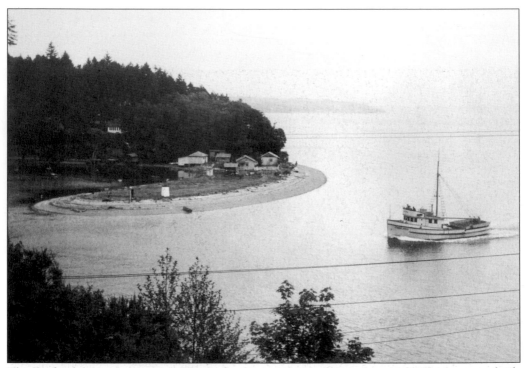

The *Freeland* skims the waters of Washington's coast as it takes its "sea trial." The boat was built for Tony Martinis Sr. in 1946 by Tacoma Boat in Tacoma, Washington. Tony owned and fished with the boat until he retired in 1977. His son Paul purchased the boat, fishing with it until its 2005 sale to Mark Russo of San Francisco, California. (Courtesy Paul Martinis.)

One

EVERETT MARINA

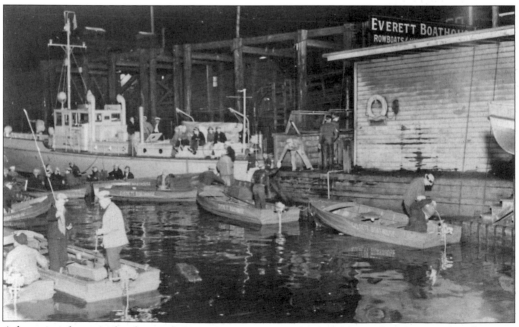

A busy, predawn rush of sport fishermen are eager to catch salmon after renting their boats at the Everett Boathouse in this c. 1930 photograph. (Courtesy Cheryl Ann Healey.)

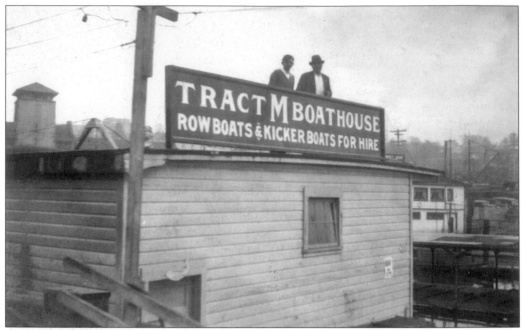

The Everett Boathouse, located at Tract M, was owned by John Marincovich and Edward Nowak. The business provided four- to six-man "kicker" boats, small gas engines, fuel, and bait for the many sport fishermen in the days before having one's own sportfishing boat was common. (Courtesy Cheryl Ann Healey.)

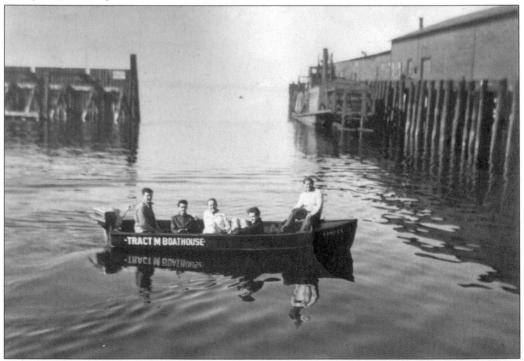

There are lots of smiles as these fishermen return from salmon fishing in their Everett Boathouse, Tract M, boat. (Courtesy Cheryl Ann Healey.)

Fishing crafts dock in front of Bryant Boats, Inc. The boats were built by J. Paul Morris under the Bryant name. It seems to be a perfect day for fishing, with calm waters, sunshine, and only a few clouds clustered in the sky. (Courtesy J. Paul Morris family.)

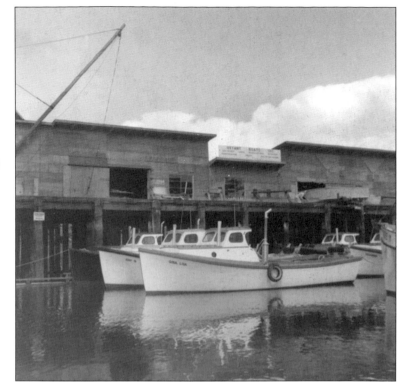

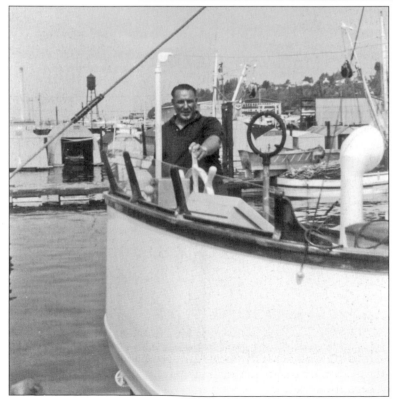

Skipper Andrew Marincovich stands aboard the *St. Christopher* in 1969. Marincovich fished in the Puget Sound and Alaskan waters, and is one of the diehards of the industry that created Everett's rich fishing dynasty. (Courtesy Katy Brekke.)

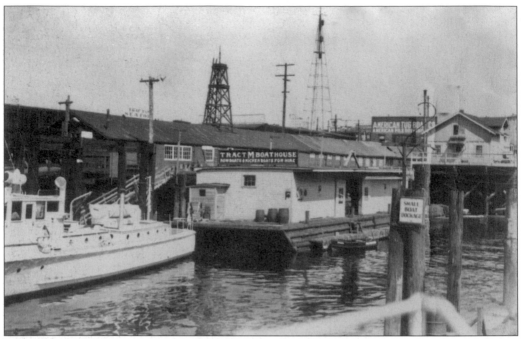

The Everett Boathouse, located at Tract M at the foot of Hewitt Avenue, was a floating barge, complete with storage for many boats, engines, and fuel. Additional waterfront businesses in the photograph include the American Tug Boat Company, Pile Driving, and Trafton's Sea Food Market. (Courtesy Cheryl Ann Healey.)

Bud Thompson's gillnetters stand at the ready for their next excursion into open waters. Bud began fishing shortly after his return from service in World War II. He was captain of both the *Josie J* and the *Kymi*. He also fished for several years with Vince Bogdanovich and other seiners. (Courtesy Orville "Bud" Thompson and Dorothy Gross Thompson.)

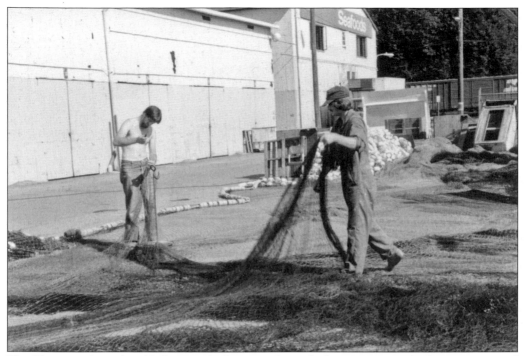

The "five-month weekend," the months between the end of one commercial salmon season and the beginning of the next, is a welcome time for most hardworking fishermen. During the off-season, fishermen give detailed attention to boats and tools. Paul Martinis, right, owner of the *DO-RO*, and a crew member repair fishing nets on the Fourteenth Street dock in front of the net sheds during the 1950s. (Courtesy Stephanie Martinis Jones.)

To reach dry dock, a boat is moved on a track in the water and then hauled in by a large winch. Dry docks are used for the construction, maintenance, and repair of ships, boats, and other watercraft. The *Wisconsin*, resting on dry dock at the Fishermen's Boat Shop, was purchased by Frank Zuanich in 1964. (Courtesy Frank Zuanich.)

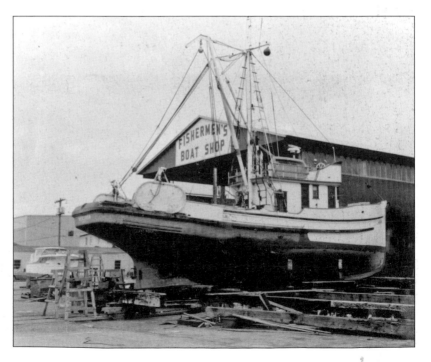

A new Sea Horse Boats 28-foot bow picker is launched at the Everett Marina. Sea Horse Boats, owned by Tim and Linda Vardy and located in Arlington, specialized in quality fiberglass and Kevlar fabrications. Boatbuilding was always scheduled to enable Tim to fish from June through November of each year. Each boat was made to spec for customers from the Puget Sound and the Columbia River areas of Washington. Boats were also built for customers in California and Alaska. Tim built his own fishing boat, providing fishermen a chance to view the product hands-on. Just about all the bow pickers produced for the Everett fleet were launched and moored on the commercial dock area of the Port of Everett. (Courtesy Tim and Linda Vardy.)

The Fourteenth Street dock is a hub of activity each fishing season. The last week ashore is filled with endless activities. From the dock, provisions are loaded, nets are brought aboard, and each crew member stores a duffel bag of clothing and personal items. The *Cheryl Ann* is just one of the many boats preparing for an extended stay on the water. (Courtesy Cheryl Ann Healey.)

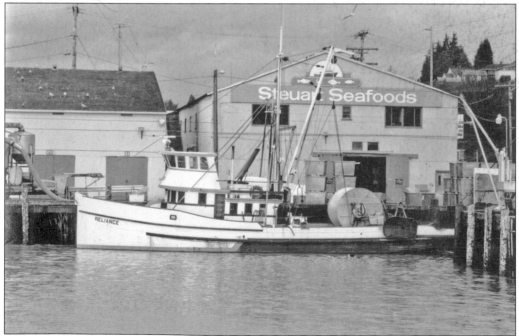

The *Reliance* moors at the Fourteenth Street dock in front of Steuart Seafoods. (Courtesy Richard C. Wright.)

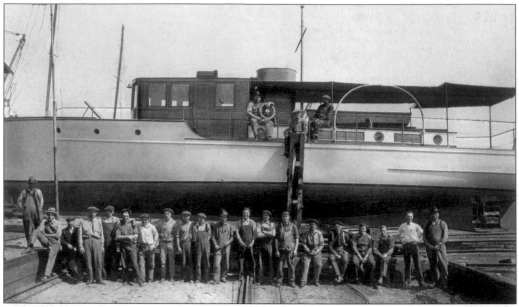

Vince Zuanich stands among the crew that built a yacht for a wealthy Everett man. The yacht was built during the off-season of commercial fishing. (Courtesy Jan Zuanich from the collection of Dr. Joseph Mardesich.)

Everett Boathouse owner John Marincovich maintained and repaired his inventory of boats and engines. He also launched numerous boats several times a day from storage. He and his wife, Lucille Mardesich Marincovich, worked from predawn to near midnight during the sport salmon fishing season prior to World War II. They also had their own bait tank, several cabins, and a café on Hat Island. (Courtesy Cheryl Ann Healey.)

From the task of mending nets, to the excitement of building a new craft, a hard-working crew stands foremost in the success of the fishing industry. Paul Martinis Sr. (right) is often considered the patriarch of Everett's fishing industry and is noted for giving several fishermen their start in the industry. The photograph above was taken at the Fishermen's Boat Shop in the winter of 1969. Pictured from left to right are (first row) Henry Wineer, Gary Krider, Dale White, Ole Shroder, Floyd Waite, Steve Philipp, Herb Joice, Walt Taubeneck, Mike Migenacco, and Leonard Cristo; (second row) ? Burns, Vic Paveevski, Aato S. Aho, Rick Waters, Don Lindblad, Mel Lameroux, Lee Brown, Boyd Kreider, Henry Sowers, Harry Richard, Jim Emory, Howard Walker, Chet Chechier, Delbert Brisbois, and Dick Eitel. (Above, courtesy Margaret Riddle from the Everett Library Collection; right, courtesy Katy Brekke.)

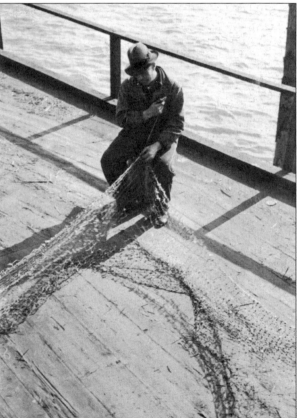

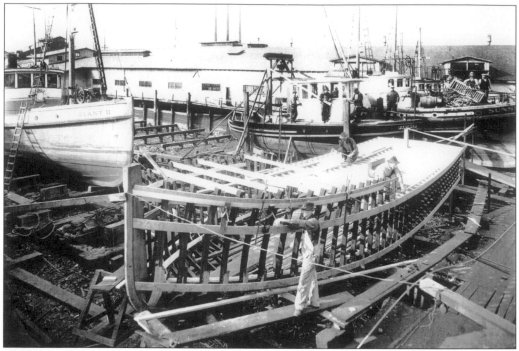

The Everett Marine Ways has witnessed nearly a century of maritime activity. In this 1929 photograph, a boat is in the beginning stages of construction. Within weeks, the craft will be christened to a busy life upon the water. At the far right, crewmen ready the *Sunset* for departure. (Courtesy Historic Port of Everett.)

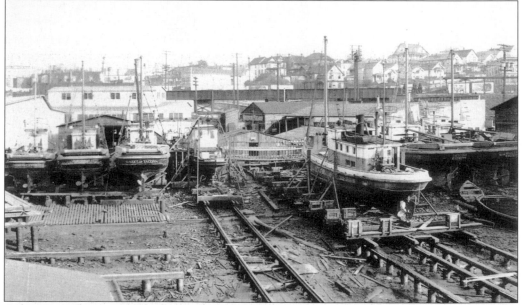

A boat is taken into dry-dock at the Everett Marina. The track allows the boat to be moved to and from the water. While in dry-dock, maintenance and repairs can take place on each boat. The boat's position on dry ground allows workers to attend to maintenance under the hull. (Courtesy Historic Port of Everett.)

Two

THE METHODS OF
FISHING

Before a single fish can be caught, the license must be in hand. This license, issued in Olympia, Washington, on September 13, 1927, was purchased for the fee of $7.50 and was paid for by the Everett Fishing Company. The license allowed Vincent P. "Wilson" Mardesich to fish for salmon with a gillnet not exceeding 750 feet in size. (Courtesy Cheryl Ann Healey.)

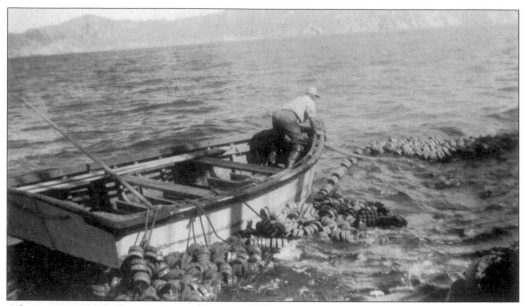

A large two-man skiff, or dory, lies aboard each purse seiner. When fish are sighted by the lookout on the bridge, the skiff is cast off, as viewed in the photograph. It remains stationary with the end of the seine attached to it. As the seine is payed out, it makes a wide circle around the school of fish. (Courtesy Kathy Padovan Wilson and Patricia Lee Padovan Myers.)

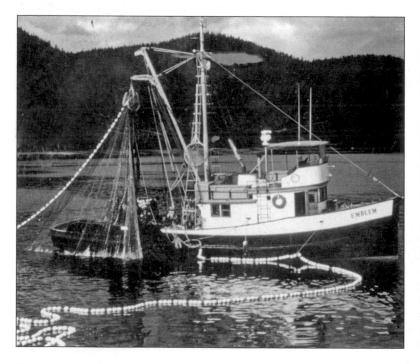

The operation of a purse seine is similar to a traditional-style drawstring purse. A number of rings exist along the bottom of a purse seine, and a rope passes through the rings. When the rope is pulled, it draws the rings close together, preventing the fish from swimming down to escape the net. A purse seine is approximately 1,800 feet by 125 feet. (Courtesy Susie and Jon Borovina.)

Purse seining is a preferred technique for capturing fish species that school close to the surface. In Puget Sound and Alaskan waters, salmon, Pacific cod, pollock, and herring are targeted by purse seiners. The crew of the *DO-RO* waits for salmon to enter their net before closing the purse. (Courtesy Stephanie Martinis Jones.)

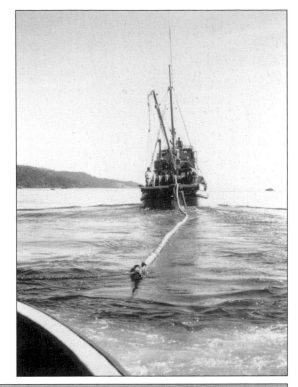

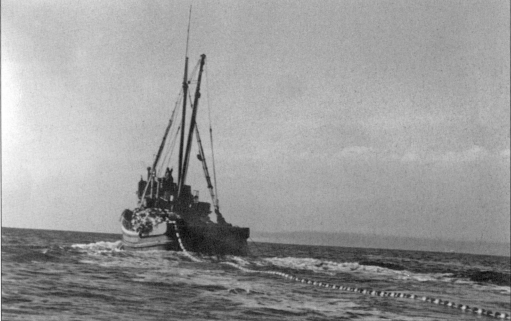

The *Wonderland* sets a net near the San Juan Islands in 1950. Seining fish requires great skill. Many conditions are given consideration, including the speed of the fish, the direction they are traveling, and the direction and speed of the tide. The net must be laid an appropriate distance from approaching fish. Care must be taken that the fish will travel above the lead line. (Courtesy Katy Marincovich Brekke.)

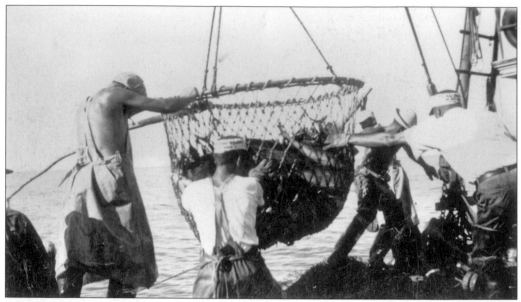

After the seine is pulled aboard the ship, a strong boom on the ship hauls (or brails) the fish from the seine into the hull storage. The brailer, a large dip net with an attached 10-foot handle by which the net is steered through the mass of fish, scoops the fish at about one ton each time. (Courtesy Kathy Padovan Wilson and Patricia Lee Padovan.)

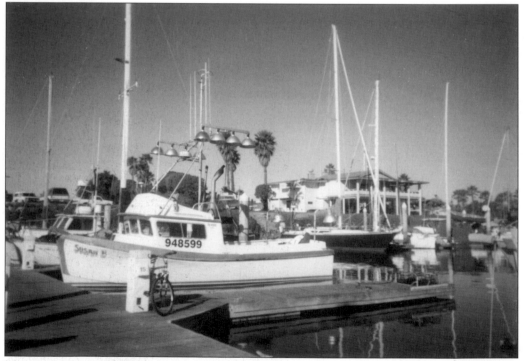

The squid-fishing light ship the *Susan B*, owned by Jon "Jay" Borovina, often fished near Channel Island out of Ventura, California. Squid fishermen work in pairs: one vessel is the light boat, flashing light into the water to attract the squid from their shelters of weed and rock. The other vessel houses the nets used to catch the squid. (Courtesy Jon and Susan Borovina.)

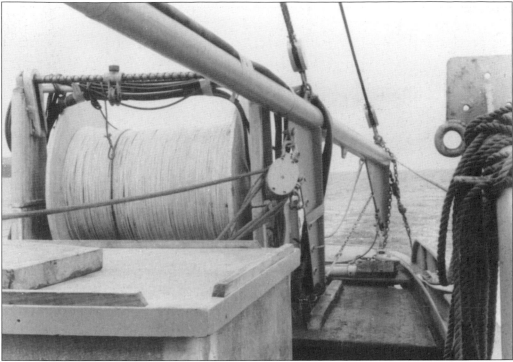

The *Bessie B* fishes for halibut in Alaska using the "longline" method. The gear consists of leaded ground lines called "skates" that hold approximately 100 hooks along its length. The baited skates are tied together and laid on the ocean bottom with anchors at each end. A set covering miles of ocean floor is fished from two to 20 hours before being pulled up by a hydraulic puller. (Courtesy Jack Rookaird.)

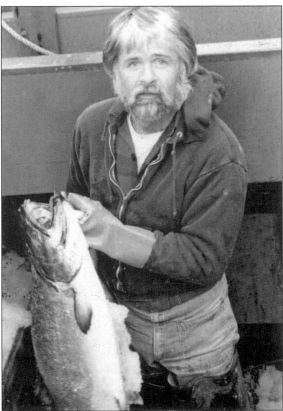

Phil Cunningham displays a troll-caught salmon. His boat, the *Juanita C*, was built as a combination trawler and gillnetter for salmon and herring fishing in both the Puget Sound and southeast Alaska. Phil also owned the *Juanita C I* and *Juanita C II*. (Courtesy Phil and Cora Cunningham.)

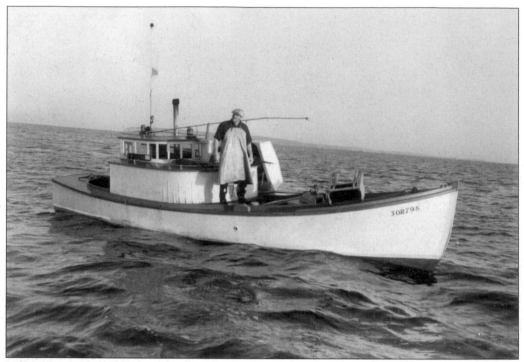

Harold Larsen spends time on his bow picker gillnetter, the *Clansman*, in 1952. Harold came from the country of Norway in 1923 at the age of 19. He became a commercial fisherman, fishing out of Puget Sound and Blaine. He also fished for herring in Alaska. Occasionally, his wife, Ruth, would travel with him on fishing trips to keep him company. (Courtesy Betty Larsen Hammer.)

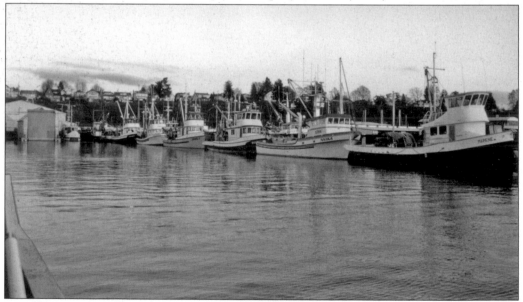

Six gillnetters, including the *Gambler*, owned by Don McGhee Sr., await the opening of the 2000 salmon fishing season. The gill net on each boat is made of lightweight netting. It is played out by the reel or by hand, then allowed to drift with the tide. The net can measure up to 1,500 feet, with fishermen adapting the length and gear to meet local conditions. (Courtesy Janice McGhee.)

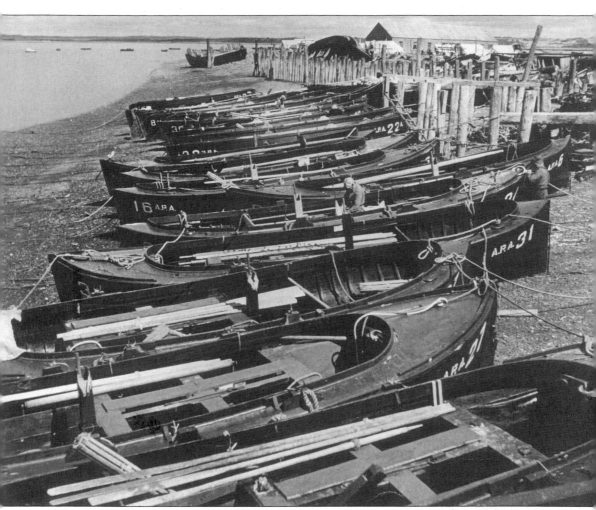

Bumble Bee sail gillnetters rest on the beach at Naknek, Alaska, in the Bristol Bay area in 1948. Gillnetters are smaller than purse seiners, fish at night, and are usually operated by only one man. Gill nets are constructed and used in a manner where fish swimming into it are usually caught by their gill covers. Some fish also become entangled when their teeth and fins are snagged. The size of the mesh in a gill net, along with the fisherman's experienced knowledge of the behavior of the fish he is seeking, ensures that bycatch of other species will be minimized. Management plans for each species of fish mandate mesh sizes, which usually range from four to 12 inches. Smaller fish generally swim through the mesh, but even when smaller fish or non-targeted species are caught, regular tending of the net by the fisherman ensures that many of them are released alive. (Courtesy Phil Cunningham.)

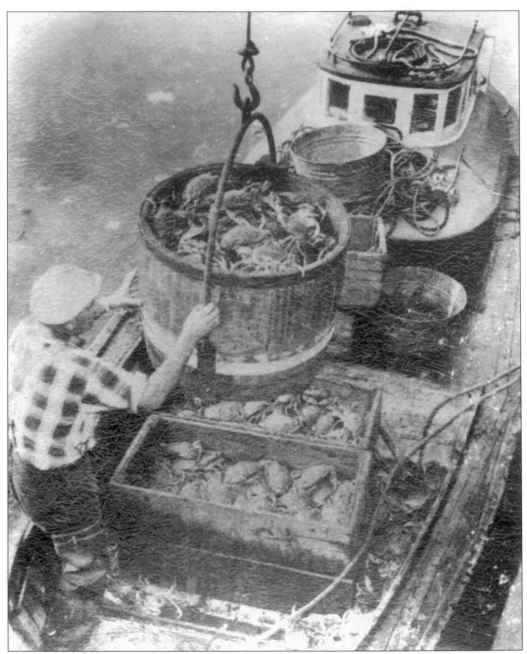

Jack Moskovita was a familiar figure on the Everett waterfront for more than 50 years. Jack crewed with Everett seiners for a few years in the 1940s but was best known around Everett as "The Crab King." Commercial watermen, such as Jack, use crab traps (or crab pots) to capture and bring in their catch. A good bait—such as dogfish livers, herring, cod, or pollock—is needed to lure the crabs inside. The traps are lowered from crabbing boats to the floor of the waterway and marked with a buoy. Most watermen check and rebait their traps daily. Modern boats utilize a motorized line hauler to hoist the crab traps. As the crabs are harvested, they are culled (sorted by size and type) and placed in containers. This photograph of Jack and his catch of crabs was likely taken in the 1950s. (Courtesy Richard C. Wright.)

Three

TOOLS OF THE TRADE

Mending net is an age-old duty for fishermen. The detailed task seems delicate and tedious for a man's large hands, but the coarseness of the net and twine, combined with the pressure of the needles, proved enough to callous even the toughest of fingers. (Courtesy Frank Zuanich.)

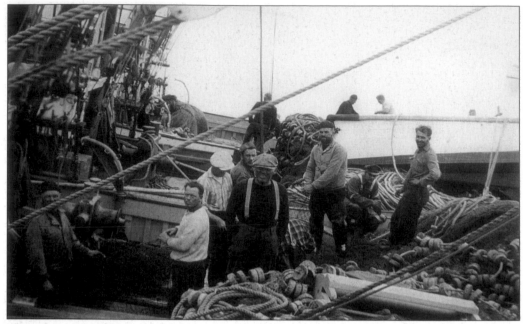

The success of a fishing season depends greatly on advance preparation. The strips of each net are sewn together by hand with heavy twine using hand-carved needles (pictured below). The nets are also preserved with oil or tar to help them withstand the salty waters of the ocean. A cork line is hung around the outer top edge of the seine, allowing for buoyancy and control of the net. A lead line positioned along the bottom of the seine makes the seine hang straight down, giving it a dish-like appearance. Attached to the bottom are bridles. Each bridle holds an iron ring through which the "purse" or haul-in line draws through. (Above, courtesy Jan Zuanich from the collection of Dr. Joseph Mardesich; below, courtesy Barbara Piercey.)

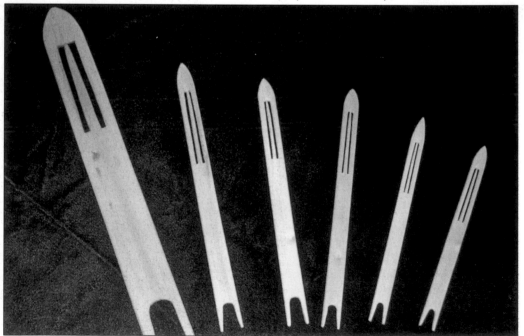

Joe Lucin mends net aboard the *Wisconsin*. It was the goal of each fisherman to completely repair hundreds of feet of net by the June salmon season opener. (Courtesy Richard C. Wright.)

A crewman relaxes against a pile of cork line and net while aboard the *DO-RO* in the 1940s or 1950s. This same net, when brought back from fishing, would be hung from rafters in the net sheds. Tony Martinis Sr. devised a screen door that would lower and cover the entire doorway of his net shed, allowing the door to remain open to promote air circulation. (Courtesy Stephanie Martinis Jones.)

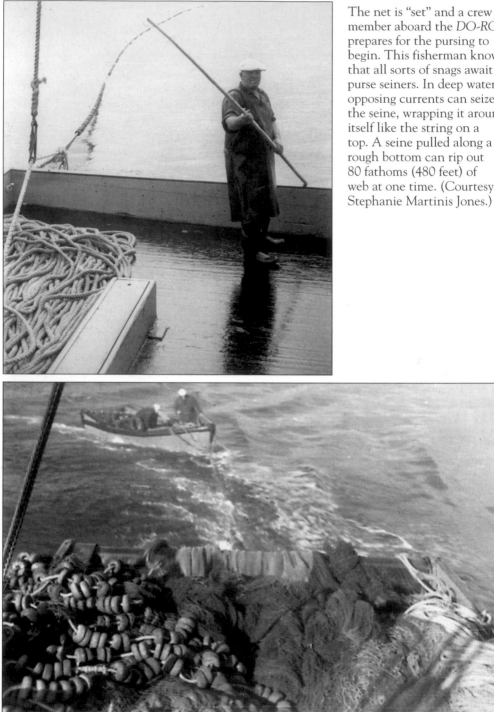

The net is "set" and a crew member aboard the *DO-RO* prepares for the pursing to begin. This fisherman knows that all sorts of snags await purse seiners. In deep water, opposing currents can seize the seine, wrapping it around itself like the string on a top. A seine pulled along a rough bottom can rip out 80 fathoms (480 feet) of web at one time. (Courtesy Stephanie Martinis Jones.)

The skiff of the *DO-RO* prepares to set the net and cork line from the table of the fishing vessel in the late 1940s or early 1950s. At this time, the skiff, a small, flat-bottom boat, maneuvered through the waters with a gas-powered engine. Until the late 1930s, skiffs were propelled the old-fashioned way—a couple of oars and a lot of muscle. (Courtesy Stephanie Martinis Jones.)

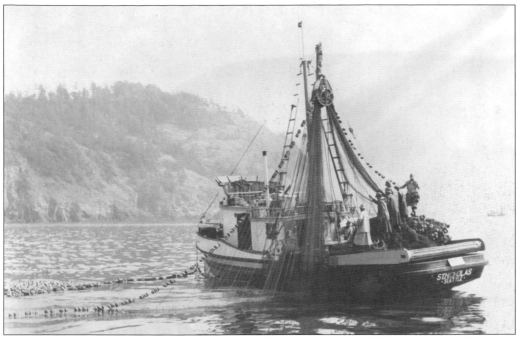

A purse seine gracefully trailing its craft creates a beautiful sight. The *St. Nicholas* (above) was owned by Capt. Anton Separovich and Paul Plenkovich. Aboard the *St. Nicholas*, drifting through the Rosario fishing grounds in the mid-1950s, are Anton Separovich, Bob Plenkovich, Paul Plenkovich Jr., Tom Plenkovich, and Carlo Andrich. The *Emancipator* (below) also skims the waters of the Rosario fishing grounds. This late-1960s expedition included skipper Nick Barhanovich, Jerry Barhanovich, John Barhanovich, Henry Barbarovich, Nick Milatich, Earl Bosket, and Richard Ivelia. The Rosario fishing grounds are near the San Juan Islands in northern Puget Sound. (Both, courtesy Margaret Barhanovich and family.)

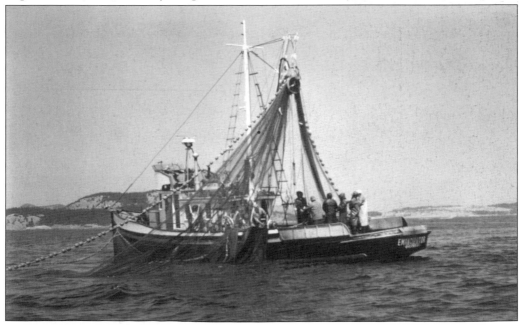

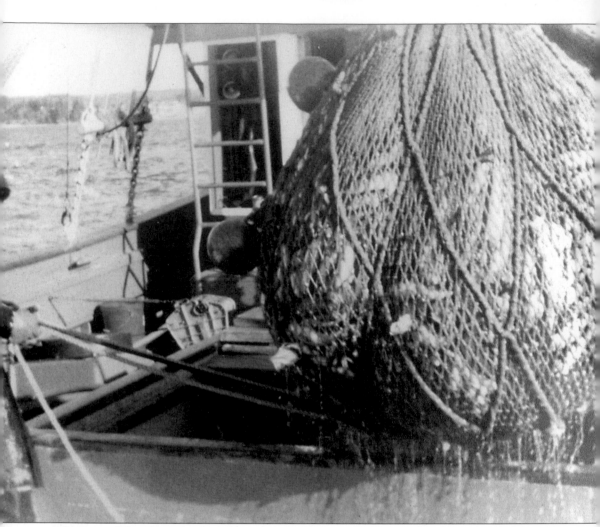

The Zuanich brothers, Andy and Frank, brought more than five million pounds of hake in from Port Gardner within two months. Their boats, the *Voyager* and the *Wisconsin*, were equipped with fish-finder equipment that operated like a depth sounder to locate schools of hake. The hake were processed at the Puget Sound Byproducts Company, located on the Snohomish River between Everett and Marysville. At the time, the federal government subsidized the hake fishery on the coast, assisting in experiments with the processing of hake for human consumption. Once while unloading the hake through an eight-inch suction pump at Puget Sound Byproducts, a dogfish that had been caught with the hake jammed in the suction pump. Before operations could be stopped, a ton of hake shot out of the top of the pipe onto the roof of the processing plant. In this photograph, the *Wisconsin* is shown off Camano Island in 1971–1972 with a net full of hake. (Courtesy Frank Zuanich.)

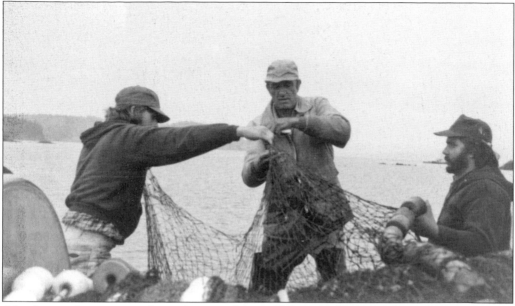

After hours of waiting, it takes only one sighting of fish to get the nets rolling off the huge drum and into the water. The crew rushes around the boat, each performing their role with practiced efficiency. Standing at the center of this photograph is Paul Martinis, skipper of the *DO-RO*. He and his crew members prepare for a fulfilling catch. (Courtesy Stephanie Martinis Jones.)

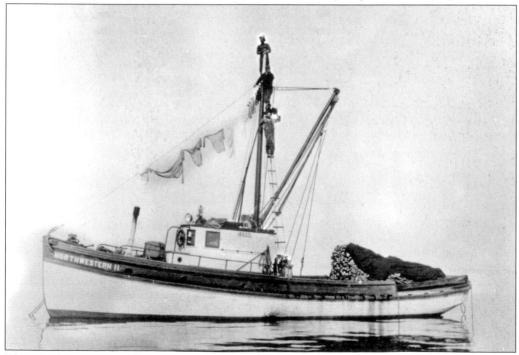

The *Northwestern II* was built in 1914 at the John Flem Shipyard in Seattle. Perched atop the rigging are three of fisherman August Leese's five sons: Albert, Walter, and William. The rigging, a series of ropes, wires, and pulleys, supports the masts and controls the sails of the boat. (Courtesy Bill and Charlene Leese.)

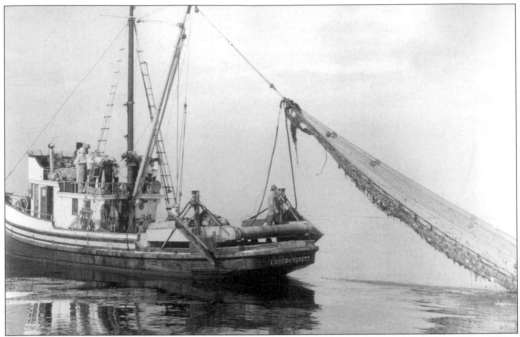

During the winter months, the Lemes fished for sole and cod fish from the inside waters of the Puget Sound. As the net flows gracefully behind their craft, powerful winches casually haul in the seine. (Courtesy Frana Barcott Hoglund and Erv Hoglund.)

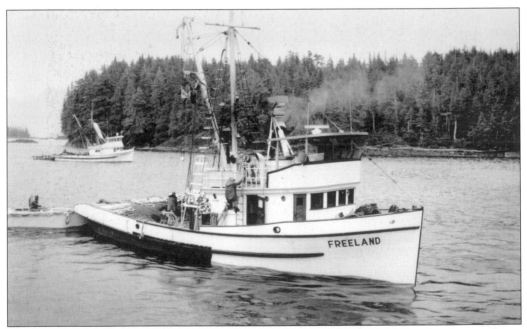

Built in 1946 by Tony Martinis Sr., the *Freeland* featured a heavy-duty diesel engine and was equipped with land-to-sea phones, built-in refrigeration, and other modern machinery. The *Freeland* was highly advanced when compared to the *Sloga II*, a boat owned by his father-in-law, Tony Mardesich, in the early 1900s. (Courtesy Richard C. Wright.)

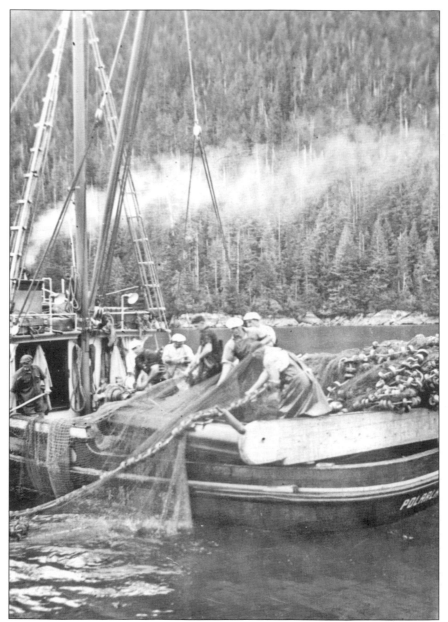

By pure strength, the crew aboard the *Polarland* hauls in a net heavy with salmon. This image was captured before the invention of the power block in the early 1950s. The power block, envisioned and designed by Mario Puretich, a Croatian who came to the United States in 1938, looks like a large pulley with an aluminum shell and a hard rubber sheave. The central rotating element hauls the heavy purse seines with their catch. It took several months for Puretich to refine his design. The prototype tested out perfectly, but interest in the new tool lagged until Marco, a marine construction and design company in Seattle, recognized its potential. A production line for the product was soon developed, and fishermen soon realized the practicality of the work-saving device. Power blocks were designed for impatient skippers on a first-come, first-served basis. By 1960, most vessels in Washington's fleet had installed the power block. (Courtesy Stephanie Martinis Jones.)

Brothers Frank (left) and Andy "Muzzy" (right) Zuanich work on the winch aboard the *Wisconsin*. The third man (above) is unidentified. The winch is used for bottom fishing. A net shaped like a stocking hat drags along the bottom of the sea. Two door-like objects are attached to the cables from the winch. When the net is released into the sea, the doors force the net to stay open as it drags the ocean floor. (Courtesy Frank Zuanich.)

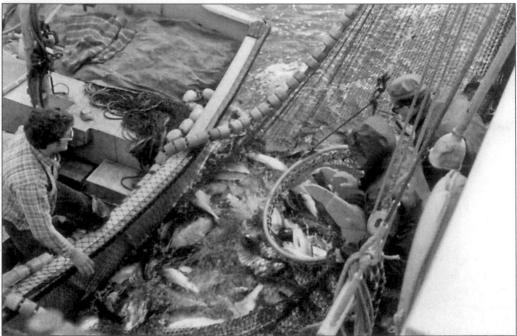

Skipper Paul Martinis (left) and his crewmen check their seine of fish. Fellow skipper Frank Zuanich can attest that fish are not the only things snagged in nets. The *Wisconsin*'s nets once lifted a hefty load—a large section of a P-38 fighter plane. The World War II aircraft, once based at Everett's Paine Field, had crashed into the bay more than 20 years before. (Courtesy Stephanie Martinis Jones.)

Nick Barhanovich stands aboard the *DO-RO*. A typical day fishing would start just before daybreak when the crew would roll out of their bunks and have a quick breakfast. The entire day was spent fishing, with the boats moving from one place to another if fishing was poor. Sunset brought the end of the work day and a time for rest. (Courtesy Stephanie Martinis Jones.)

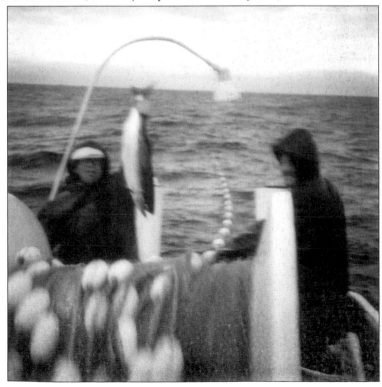

A gillnetter working in the dark relies on light from his boat to see the net as it is pulled in. He then picks the fish out of the net. (Courtesy Orville "Bud" Thompson and Dorothy Gross Thompson.)

Noel Gallanger (left) and Richard Jackson of Everett admire a newly installed flying bridge on the gillnetter *Little Rich* at the Port of Everett fisherman's moorage in 1981. This open area acts as an elevated steering position on top of the boat's cabin. Inside, a wall of electronic equipment is proof of the industry's technological advancements. Until about 1930, the men fished with no radar or radio. Instead they depended on the stars, a compass, and nature's landmarks to determine their course through the water. A lead line determined the depth of the water, and pure strength and determination hefted the tremendous weight of the catch into the confines of the boat. Of course, history shows that the most advanced technology came as fish runs began to dwindle. Matt Marincovich summed it up succinctly in an *Everett Herald* news article by Lloyd Spence: "Every year the fishing boats get more complicated. And every year the fish get scarcer." (Courtesy Jill Jackson.)

Dick Padovan captured this image of Jerry Solie tending a set net site in Bristol Bay, Alaska, in 1985. Set net fishing is a one-man operation. The gill net is set close to the shoreline, and the fisherman "picks" the salmon from the net into his small boat. (Courtesy Jerry Solie.)

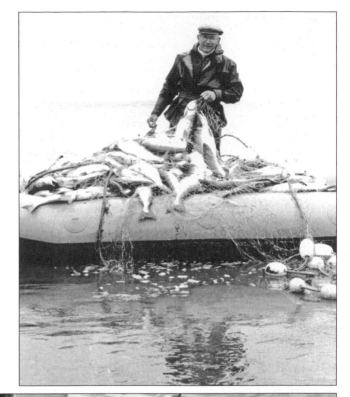

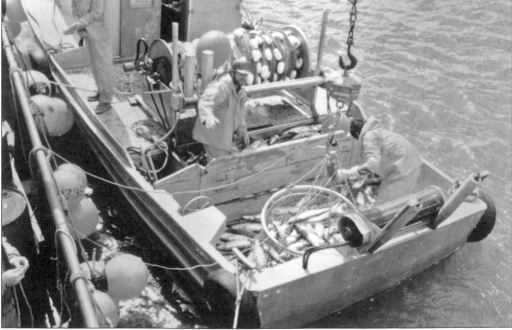

This bird's-eye view of the *Katherine B* shows off a beautiful catch of fish. Here the *Katherine B* has pulled up alongside the buyer. The fish will be handpicked by the gillnetter from the brailer then transferred to the buyer. Crewman Scott Higley stands in the middle of the action. (Courtesy Guy and Gwen Piercey.)

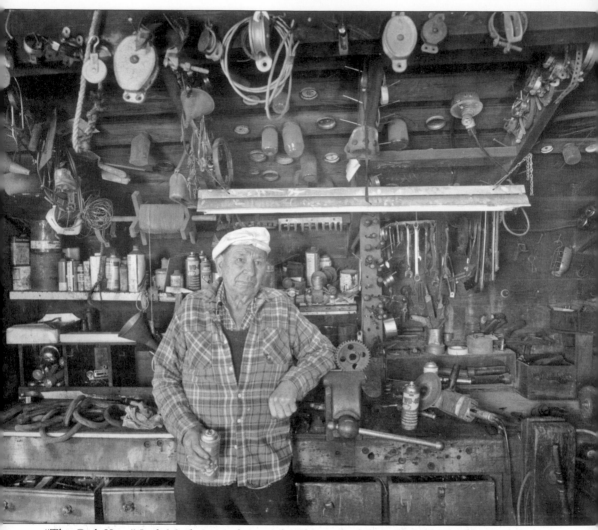

"The Crab King" Jack Moskovita relaxes at his shop, which he called "the building." Jack spent many hours fixing things to sell in his shop. He had many used engine parts, propellers, and tools of the trade for sale. On the water, however, with no parts shop in sight, neighboring boats became the source for supplies. Despite the fishermen's fierce competitive natures, if a fellow fisherman is in great trouble and in need of parts, another crew will often lend a helping hand, sometimes at a great potential loss of income. (Courtesy Richard C. Wright.)

Four

THE CATCH

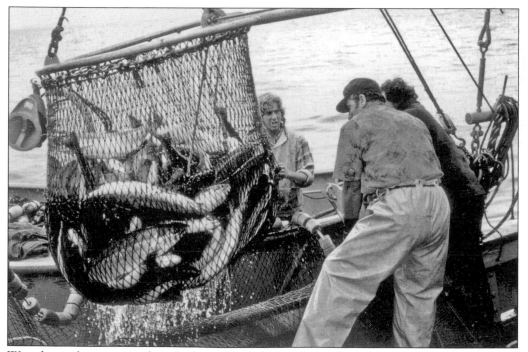

Wriggling salmon are ready to be brought on deck and into the hold of the *DO-RO*. Later the seiner will anchor next to a tender for transfer of the load. Two deckhands within the hatch will remove thousands of fish, one by one with a picaroon (or gaff) into a brailer. The brailer transfers the fish from the purse seiner to the tender. When all the fish are transferred, the deckhands in the hold are left with a sticky mess of jellyfish to clean up. (Courtesy Stephanie Martinis Jones.)

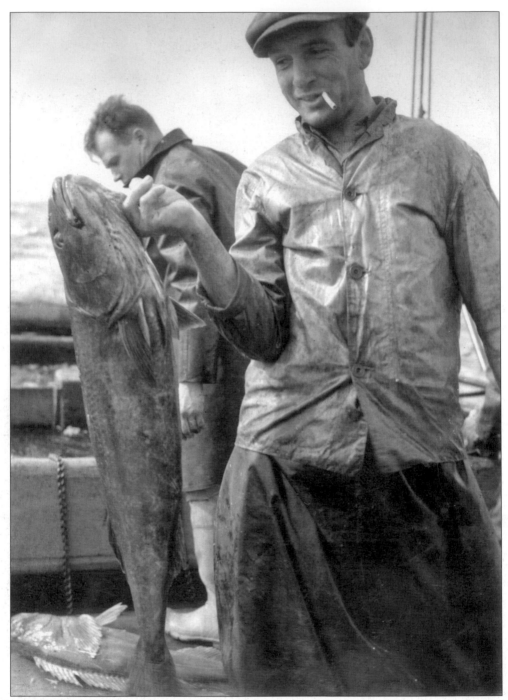

Capt. Matt Marincovich admires a fine fish caught during a March 1942 fishing expedition. Prior to travel, Matt mentally laid plans for the trip to Alaska. After a stop in Ketchikan to take on fuel, water, and additional supplies, he and his crew traveled aboard the *Wonderland* across the Gulf of Alaska to False Pass. The fishing grounds, located within a few hours of False Pass, became their home away from home for about one month. From False Pass, the crew would travel 18 hours to the Bering Sea to fish for the remainder of the season. (Courtesy Katy Marincovich Brekke.)

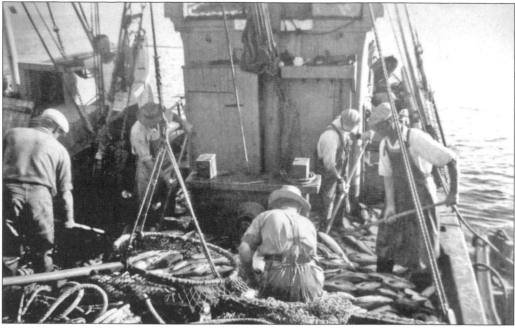

The deck on one of the Leeses' purse seiners is full of freshly caught salmon in the 1950s. The largest harvest of sockeye salmon in the world occurs in the Bristol Bay area of southwestern Alaska during a short, intensive fishery that lasts only a few weeks. (Courtesy Bill and Charlene Leese.)

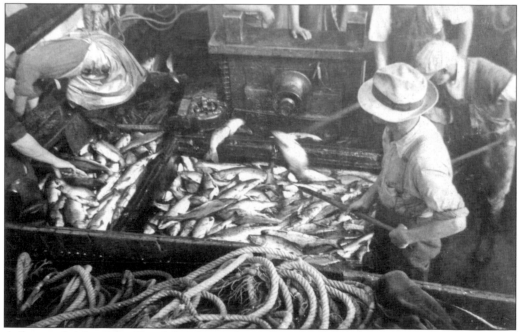

A fine catch is brought aboard the *Mermaid II* in the 1950s. Chum salmon are the most abundant commercially harvested salmon species in arctic, northwestern, and interior Alaska. Ocean-fresh chum salmon are metallic greenish-blue on the dorsal (top surface) with a spray of fine black speckles. After nearing freshwater, chum salmon change color, gaining vertical bars of green and purple. (Courtesy Bill and Charlene Leese.)

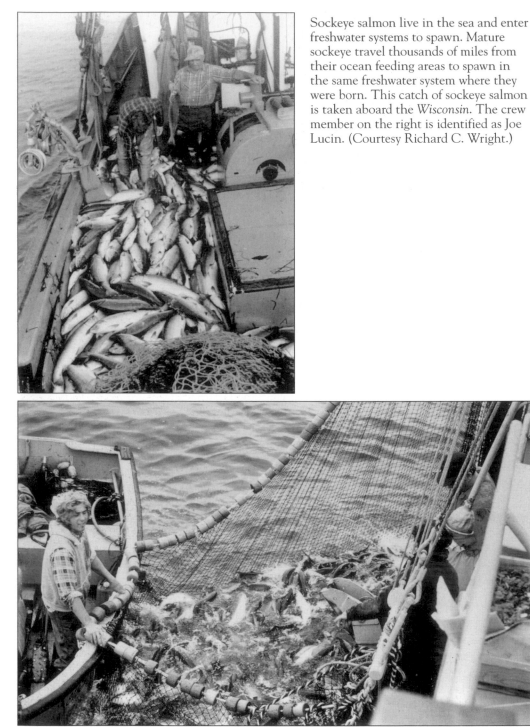

Sockeye salmon live in the sea and enter freshwater systems to spawn. Mature sockeye travel thousands of miles from their ocean feeding areas to spawn in the same freshwater system where they were born. This catch of sockeye salmon is taken aboard the *Wisconsin*. The crew member on the right is identified as Joe Lucin. (Courtesy Richard C. Wright.)

A power block assists the crew of the *DO-RO* in bringing the net full of salmon on deck. The skiff, located on the left, is instrumental in pulling the net into position for the set. The skiff man works alone on the skiff, which measures around 16 to 18 feet in length. If it is stormy, he is out alone in the elements during the set. (Courtesy Stephanie Martinis Jones.)

44

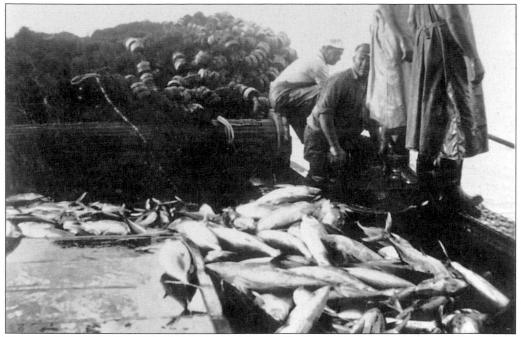

Everett's fishermen are a tight-knit group working together to bring in harvests to support their families. A fisherman may captain his own boat then later help aboard a friend's vessel. Pete Padovan, for instance, crewed on many fishing vessels, including those of Mike Borovina, Matt Martinis, and Frank Barcott. He was also an engineer on floating canneries. These crew members are unidentified. (Courtesy Kathy Padovan Wilson and Patricia Lee Padovan Myers.)

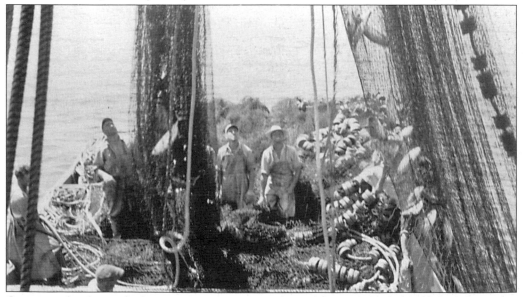

Crewmen closely watch the net containing a salmon catch as it is raised aboard the boat in this photograph from the late 1940s. Later the boat will find a fish tender and unload their daily catch. After the nets and cork lines are repositioned and other chores tended to, the crew will catch a few hours of sleep before starting the process all over again. (Courtesy Kathy Padovan Wilson and Patricia Lee Padovan Meyers.)

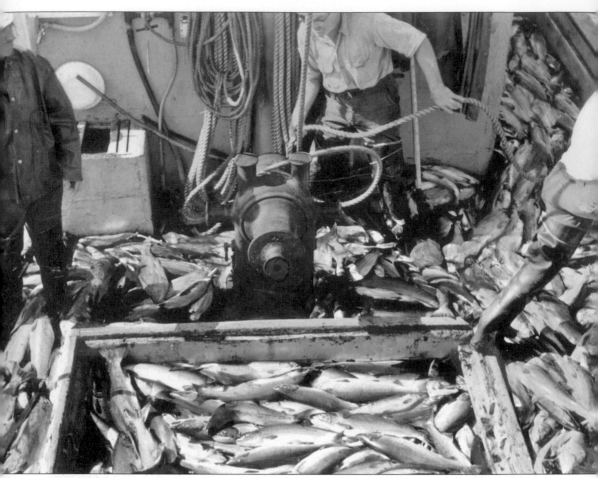

The sockeye salmon caught in a single set off Point Roberts, Washington, in September 1958 numbered 14,800. As the heavy load filled the *Emancipator*, owned by Nick Barhanovich, all the deck and walkways were filled with fish, thus blocking entries to the wheelhouse. Crew used the windows to gain entry to the interior. Ironically, at the time of this catch, the runs were running slowly, and most boats were ready to move on to other areas. Pictured are crew members John Padovan and Ingmen Nelson. (Courtesy Margaret Barhanovich and family.)

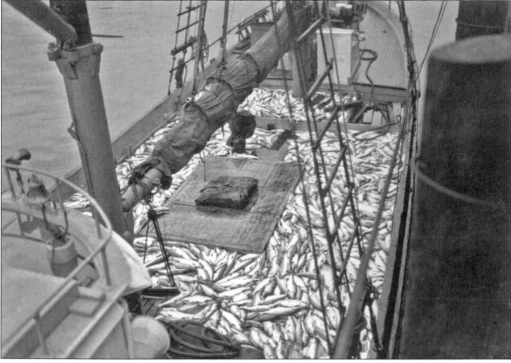

A tender loaded with salmon anchors at the cannery dock. Tenders travel to the boats, transfer their loads of fish, and make delivery to the canneries. (Courtesy Jan Zuanich from the collection of Dr. Joseph Mardesich.)

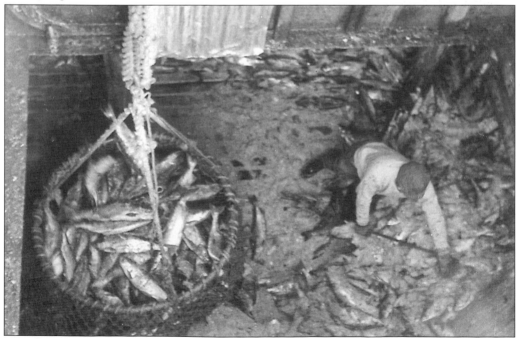

In 1952, a crew member loads frozen salmon into a dip basket from the *North Star* in Everett. (Courtesy Jan Zuanich from the collection of Dr. Joseph Mardesich.)

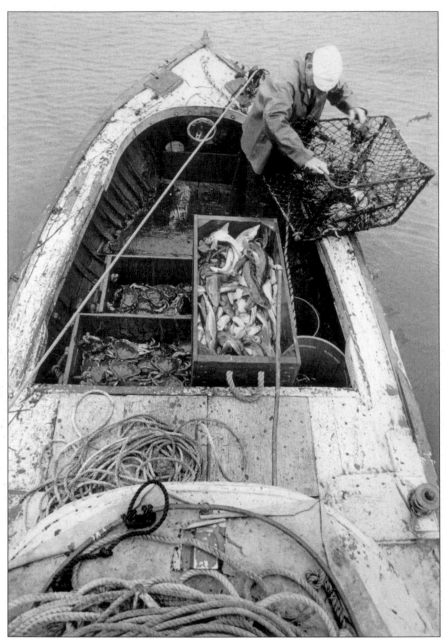

Jack Moskovita is best known for his crab sales out of the panel truck that announced his occupation, "The Crab King." Jack, following in his father's footsteps, worked in the Puget Sound area, catching an abundance of Dungeness crab over his lifetime. Dungeness crab gets its name from the town of Dungeness, located near Sequim, Washington. Averaging six to seven inches across the back, the Dungeness crab is purple-tinged with grayish-brown on the back and white-tipped claws. It is often considered the sweetest of all crab. For the crab fisherman working in Alaska, three species of king crab are caught commercially: the red king crab, found in Bristol Bay, Norton Sound, and the Kodiak Archipelago; the blue king crab, found near St. Matthew Island and the Pribilof Islands; and the golden king crab, found near the Aleutian Islands. The red king crab is the most prized of these three for its meat. (Courtesy Richard C. Wright.)

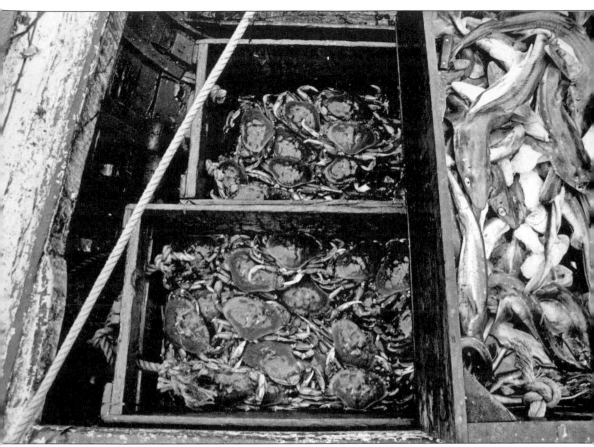

A container of bait rests next to a day's catch of crab. Jack Moskovita chose dogfish as his bait for this crabbing trip. Herring also makes excellent bait. As the pot is pulled up—40 or so pulls—the anticipation for any commercial crab fisherman builds. A pot full of color means a paycheck for the family. Small crabs are gingerly tossed back into the water; larger crabs are keepers if they meet the state's crab size limits. They are carefully grabbed by the two back legs so the large, fearsome pincers cannot reach the fisherman's fingers. (Courtesy Richard C. Wright.)

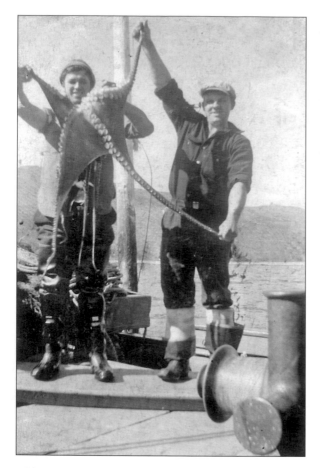

John Borovina Jr. (right) displays a recently caught octopus. Fishermen are all smiles when an octopus is brought onboard. Often, a crewman eager for a taste of the delicacy will pull out a pocket knife, cut off the tip of a tentacle, and pop it in his mouth. Later the ship's cook will tenderize the meat by pounding it against a hard surface before preparing it. (Courtesy Jon and Susan Borovina.)

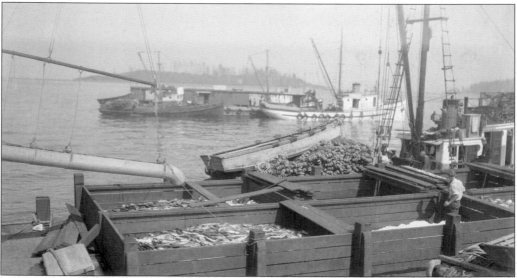

Crewmen take on the arduous task of moving fish from the seiner to the tender. Each fish weighs around five pounds and is individually lifted into the brailer using a picaroon (a type of gaff). A good catch of fish numbers in the thousands. (Courtesy Stephanie Martinis Jones.)

Sore arms are part of the job for a fisherman, especially for the "lucky" souls who work with the picaroon. This *DO-RO* crew member uses a gaff called a picaroon to transfer thousands of salmon from the seiner to the tender's brailer. The picaroon has a broom-like handle with a sharp steel point used to pierce the salmon's head to lift and throw it into the brailer. (Courtesy Stephanie Martinis Jones.)

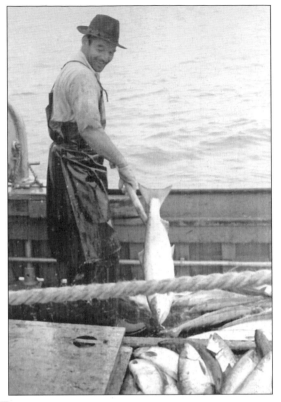

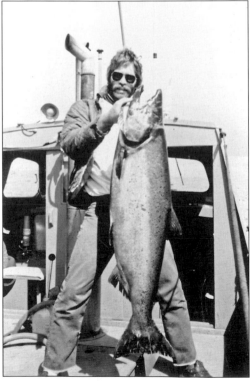

Joel Ludwig caught this 40-pound Chinook salmon in 1983 aboard the *Stanvic* in Bristol Bay, Alaska. Chinook salmon, often called king salmon, is Alaska's state fish and one of the most important commercial fish native to the Pacific coast of North America. It is the largest of all Pacific salmon, with the weight of an individual fish often exceeding 30 pounds. (Courtesy Joel Ludwig.)

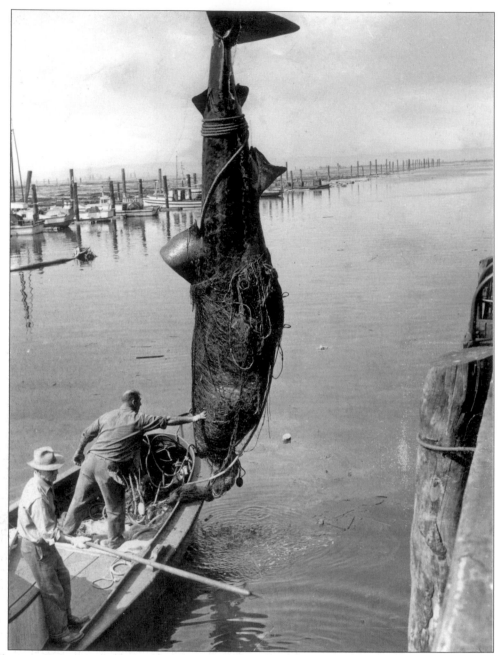

The sixgill shark, a common species of deepwater shark, is one of the largest sharks that feed on prey other than plankton. Often growing to a length of up to 18 feet, these sharks have the unique ability to change their color for short periods of time. Since they are slow swimmers, they blend into the background and approach faster-swimming fish undetected. They are not usually dangerous to humans unless provoked. Sixgill sharks are found all over the world and have been known to dive as deep as 6,000 feet. They swim up to shallower waters at night to feed. This sixgill shark was caught in Port Gardner Bay and landed at the Fourteenth Street net sheds at the Port of Everett in 1950. John Padovan stands aboard the Columbia River bow picker gillnetter. (Courtesy Ron Erickson.)

Five

In Alaskan Waters

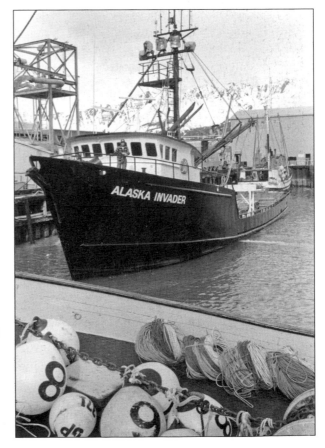

The *Alaska Invader* skims the waters of southeast Alaska in the late 1980s. Under contract to tender the herring fishery, it included a crew of three. The tender was skippered by Ted Peterson. Chief engineer Terry Hobsen is seen on deck, and Dick Wright worked as the cook and deckhand. (Courtesy Richard C. Wright.)

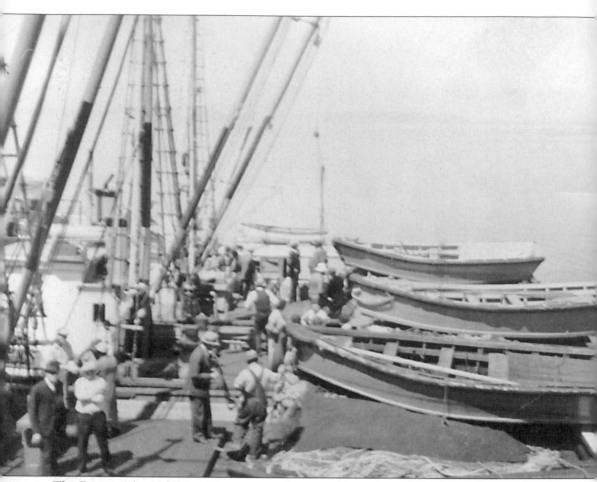

The Everett salmon fishing fleet prepares for its yearly trip to Alaska. "Get Away Day" was a big event. Flags would fly from mastheads, and air horns would blast their goodbye as the boats pulled away from their mooring places alongside the Fishermen's Packing Corporation dock or the adjacent Pier One on Everett's waterfront. From the early 1920s into the early 1930s, each skipper wore a dress jacket and hat for the occasion. Families of the fishermen would crowd the docks, sometimes accompanying their loved ones on the fishing vessel for some miles. Off Hat Island, the seiners would lash themselves together to form a huge base for a farewell party. After the party, family and friends who were not making the long trip north boarded another boat returning to Everett, such as Ed Taylor's yacht, the *Faun*; Otto Johnson's *Hobby*; or Joe Dragovich's seiner, *Congress*. (Courtesy Wini Joncich Mardesich.)

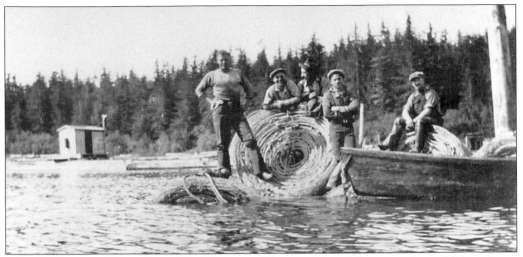

As new canneries developed, fishermen realized they could catch huge numbers of fish in large, stationary traps rather than using boats. Locals and boat fishermen, however, decided the commercial traps were too efficient for their own welfare, and the fish traps became the center of a 50-year political battle. In addition, concern about dwindling fish runs caught the public's eye. Although no attempt was made to ascertain the extent the traps affected the fishing economy, fears of exploitation of Alaska's salmon came to a head prior to Alaska's reception of statehood. In 1959, the state of Alaska banned fish traps as part of its constitution. Above, Nels Egge (left) stands atop salmon fish-trap material in Craig, Alaska. The other fishermen are not identified. Below shows construction of a fish trap in Craig, Alaska, during the 1930s. (Courtesy Larry Egge.)

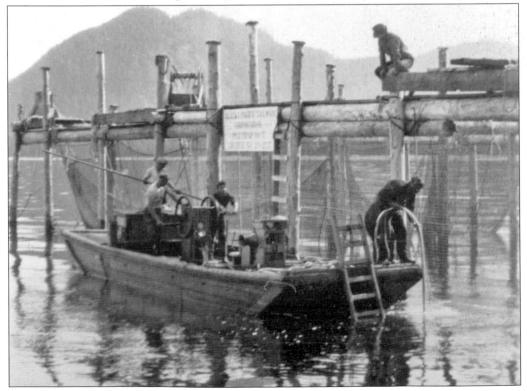

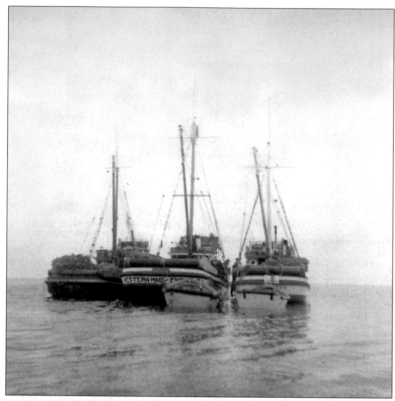

From about 1950 on, the trip from Everett to Ketchikan generally took 72 hours. From there, the boats continued north to Icy Straits, then west for the long sail across the Gulf of Alaska to False Pass. In total, the trip usually took eight to nine days. In this photograph, three Everett fishing vessels are rafted together at Port Moller, Alaska, in the 1950s. (Courtesy Leonard and Fran Zuvela.)

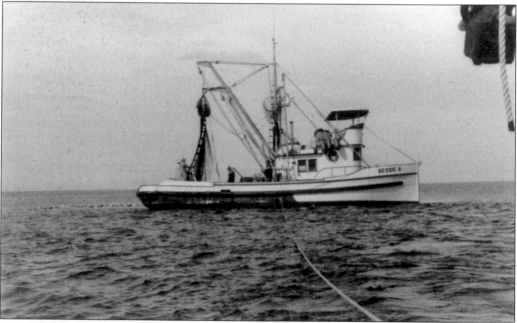

The *Bessie B* glides through the open waters near Kodiak Island, Alaska, in early September 1980. During this last set of the season, the *Bessie B* was nearly knocked over by a williwaw. The skiff nearby was also affected by the gusting winds, was nearly swamped, and lost all electrical power. (Courtesy Jack Rookaird.)

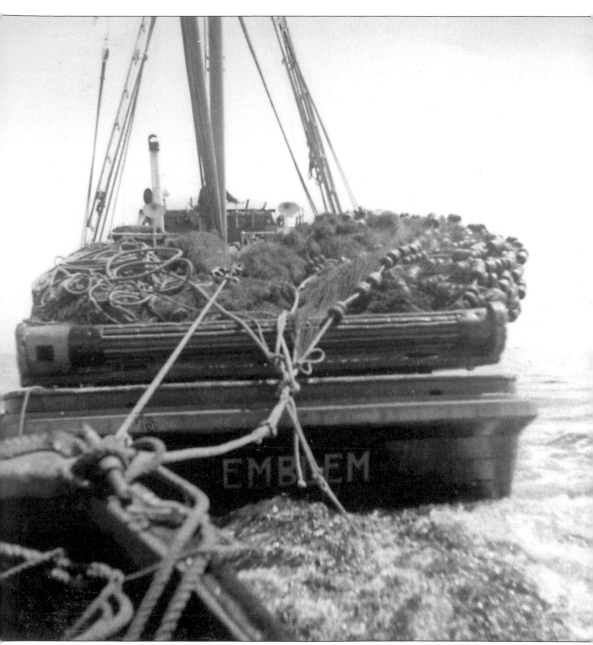

The *Emblem* enjoys a successful fish run in Alaskan waters. This photograph, taken from the boat by skiff man Leonard Zuvela, demonstrates the setting of the purse seine. Each purse seine has a turntable aft on which the seine is folded. As the turntable rotates, it permits the seine to be payed out from either side or stern, ensuring that the seine does not tangle. A set is made by pulling one end of the net into the water by means of a powered skiff, then following a semicircular route with the vessel while paying out the remainder of the net. The net is held in position against the current for varying lengths of time until the purse line is tightened and the rings and lead line are lifted aboard, completely enclosing the bottom of the net. With the fish trapped in a closed bag suspended below the floating cork line, the net is then hauled aboard the vessel. (Courtesy Leonard and Fran Zuvela.)

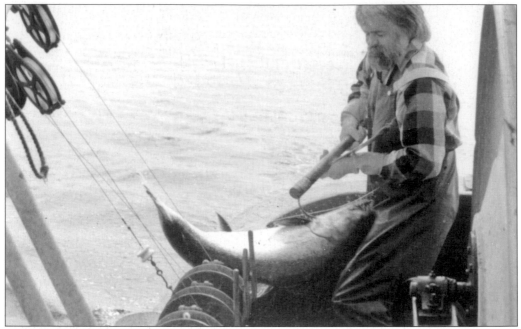

Phil Cunningham lands a nice king salmon while aboard the troller/gillnetter *Juanita C.* The Alaska king salmon is the largest species of Pacific salmon, averaging 20 pounds in weight. Its blue-gray back is usually dotted with irregular-shaped spots. This fishing trip took place in Alaska in 1973. (Courtesy Phil Cunningham.)

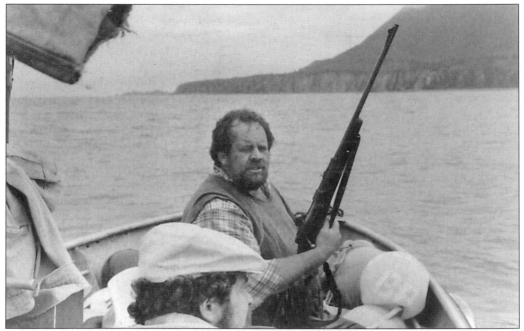

While beachcombing in July 1980, the *Bessie B* heads into Geographic Harbor near the Alaska Peninsula. Phil (the Bear) Klug keeps a careful eye out for grizzlies and Kodiak bears. His rifle is a necessary defense in this land of wilderness. Also aboard the *Bessie B* is skipper Jim Kyle of Everett. (Courtesy Jack Rookaird.)

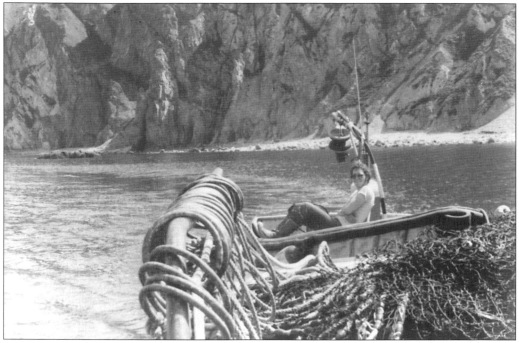

"Bewitching Kodiak! The spell of thy summer freshness and placidity is still upon me." These words, written by John Burroughs in the book *The Harriman Expedition*, ring true for the fishermen of the Kodiak region. In 1980, the beautiful, rugged cliffs of Kodiak Island provide stunning scenery for Robert Bogus, skiff man on the *Bessie B*. (Courtesy Jack Rookaird.)

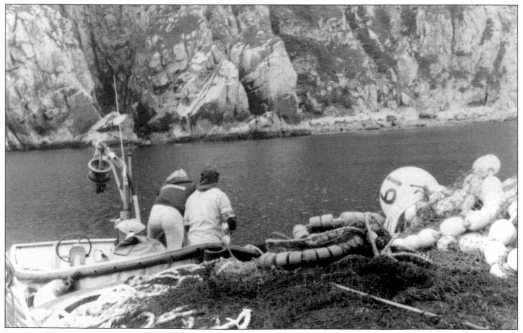

More of Kodiak's beauty is seen in this photograph. Deckhand Steve Barse (left) of Vancouver, Washington, and skiff man Robert Bogges of Everett, Washington, take in the scenery as they work aboard the *Bessie B* during the 1980 salmon season. (Courtesy Jack Rookaird.)

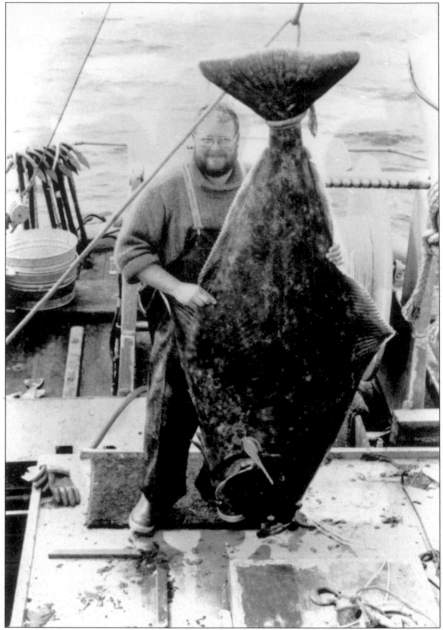

Jack Rookaird displays a prize Pacific halibut caught in Icy Strait, Alaska, near Cape Spencer during the 1980 season. The halibut, which dressed out at 235 pounds, was caught aboard the *Bessie B*, captained by James Kyle. Halibut are one of the most valuable fish species found in north Pacific waters. They are more elongated than most flatfish, with their width being about one-third their length. Most commercial fishermen use longlining to target halibut. The fishing gear is handled in units of line called "skates," with each skate usually measuring 100 fathoms (600 feet) and holding around 100 hooks baited with fish. A number of skates are attached together in a string 1,800 to 2,000 feet long to form longlines, which are normally pulled off the ocean floor by a hydraulic puller. Once onboard, the halibut are cleaned and kept on ice to retain freshness. (Courtesy Jack Rookaird.)

Six

PARTNERS OF THE INDUSTRY

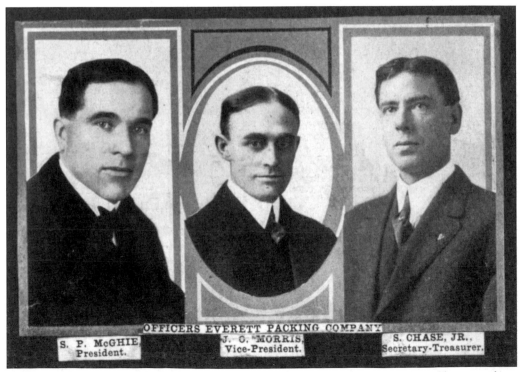

Officers of the Everett Packing Company, Inc. included, from left to right, S. P. McGhie, president; J. O. Morris, vice president; and S. Chase Jr., secretary-treasurer. (Courtesy Debra Wright.)

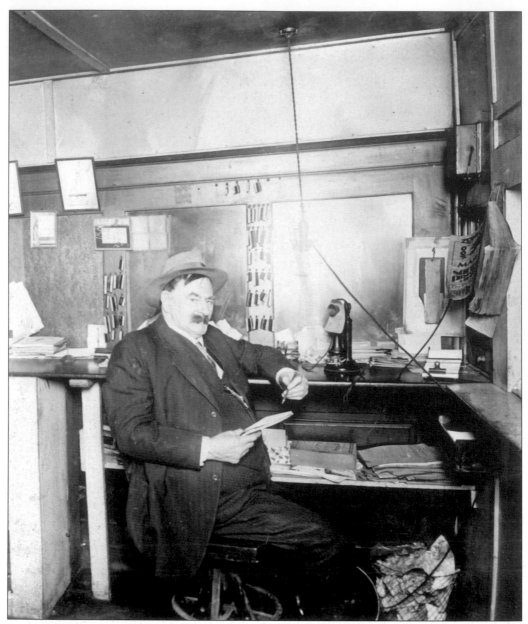

Stephen Chase, once called the oldest fisherman in the United States by the *Seattle Star* newspaper, was born in Portland, Maine, around 1850. He was involved in fishing and fish processing from an early age. This photograph, likely taken after his arrival in Seattle around 1897, shows him working at one of his businesses. He founded and owned enterprises in Maine and at least three fish companies in Washington state, including the Whiz Fish Company and the Quality Sea Food Packing Company, both in Seattle. In Everett, he founded the Everett Fish Company in 1903. The 1915 Everett City Directory lists the business location at 2924 Norton Avenue, and in 1939, it is listed at City Dock at the foot of Hewitt Avenue. Stephen never retired. He remained active in his businesses, keeping books, taking orders, and often grading fish during the busy season. (Courtesy Otto Chase.)

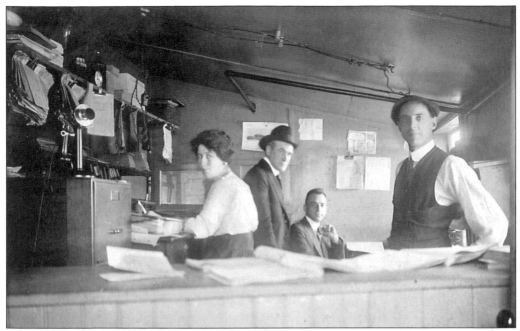

A candlestick telephone on the file cabinet is reminiscent of the old-fashioned technology involved with 1920s paperwork. At the Everett Packing Company, office staff and family members efficiently took care of billing, orders, and inventory control without computers, Internet connections, or cell phones. (Courtesy Otto Chase.)

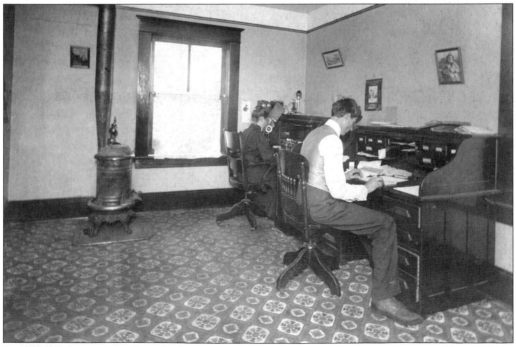

Staff members work hard at the business office of the Everett Packing Company. Natural light and large, sturdy, rolltop desks provide a good working environment. Hanging above the desk is a familiar sight—an image of a fisherman dressed for a day at sea. (Courtesy Otto Chase.)

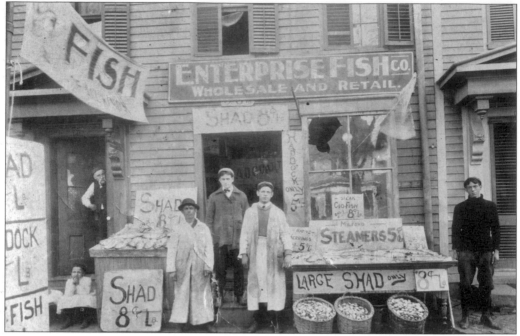

Stephen Chase also had connections with the Enterprise Fish Company, likely located in the northeast part of the country, and the Standard Fish Company, likely located in the Pacific Northwest. In the photograph above, taken during the early 1900s, shad fish sold for 8¢ a pound, Milford steamer clams for 5¢ a pound, haddock for 5¢ a pound, herring for 5¢ a pound, and steak cod fish for 8¢ a pound. The second photograph, an interior shot of the Stephen Chase Standard Fish Company, shows a pile of halibut ready to be processed. Based on the price description listed earlier, it is assumed that halibut sold for a few cents a pound in 1909. Today the price for halibut is significantly more; a 2008 advertisement listed halibut at $16 a pound. (Both, courtesy Otto Chase.)

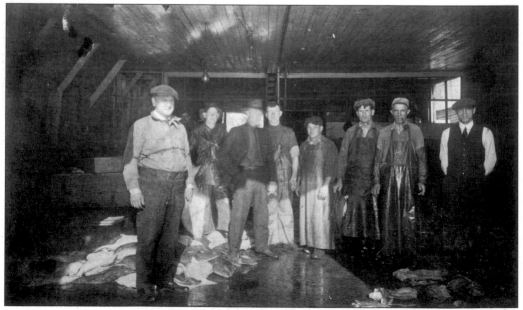

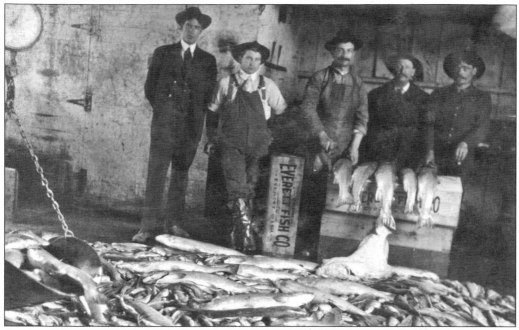

Stephen Chase and a crew of men prepare to process a load of salmon and halibut at the Everett Fish Company; the imprinted wooden box confirms the business name. A scale, visible at the left side of the photograph, proved indispensable in determining the total weight of a catch. This postcard, marked 1908, is from the collection of Ed and Betty Morrow. (Courtesy Ed and Betty Morrow.)

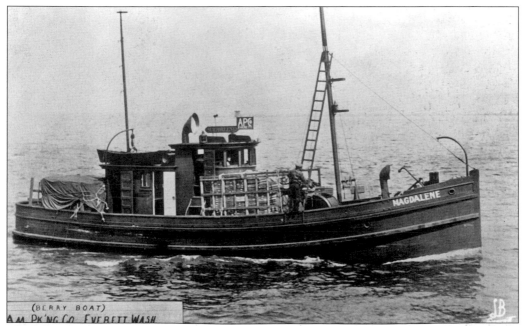

The Stephen Chase family's American Packing Company vessel, *Magdalene*, makes deliveries around the Puget Sound. The packing company processed fish, oysters, and a variety of fruits. This delivery appears to be flats of strawberries. (Courtesy Ed and Betty Morrow.)

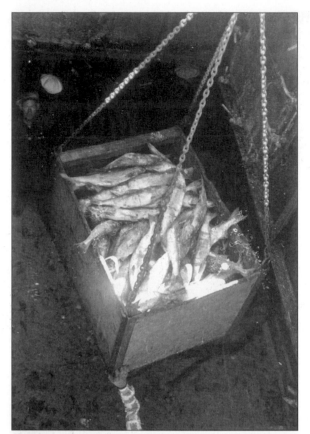

Frozen salmon is unloaded from the *North Star* in Everett in 1952. The *North Star*, like other cannery tenders and floating canneries, would pick up their day's catch from the scattered fleet. Other seiners would discharge their fish holds at receiving scows stationed at strategic points on the fishing banks. (Courtesy Jan Zuanich from the collection of Dr. Joseph Mardesich.)

Unidentified workers at the Everett Fish Company weigh and prepare to butcher a load of fresh halibut. The workers, with a sharp gleam of steel, make quick work of preparing the fish before they are sent off to the "slimehouse" where female workers will clean and hand dress each fish. (Courtesy Otto Chase.)

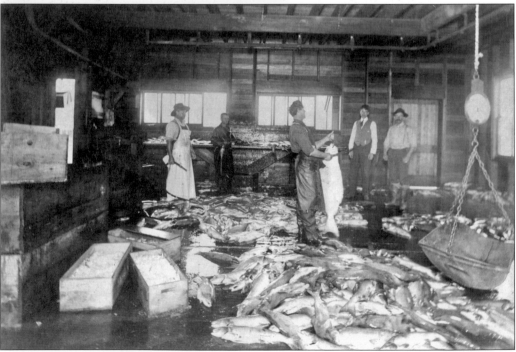

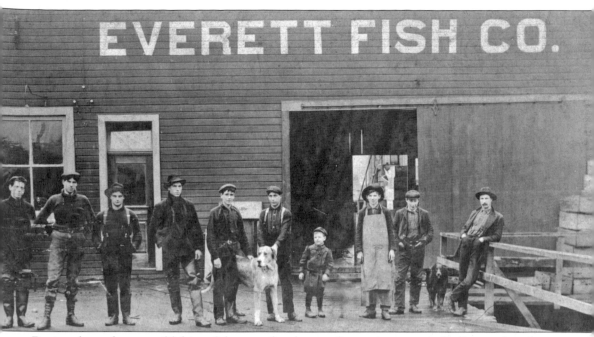

During the early years of fishing, fishermen faced many disappointments in finding markets for their catch. The law of supply and demand reigned supreme: when salmon was scarce, buyers were eager to purchase as much fish as possible. However, when the catch was plentiful, canneries turned away many boats because they had no room. These circumstances led to the invention of a new relationship between Everett's cannery and local fishermen. In 1928, vessel owners banded together to purchase the Everett Packing Corporation and form the Fisherman's Packing Corporation (FPC). The concept behind the cannery was for it to operate for the sole purpose of caring for the daily catch of the seiners. Stock in the company was only issued to boat owners actively fishing each season. After the conception of the FPC, Capt. Peter Jugovich became president, and J. O. Morris was retained as the manager of the new institution. In this photograph, taken before the transition in business names, an unidentified group of workers await the next delivery of fresh fish. (Courtesy Otto Chase.)

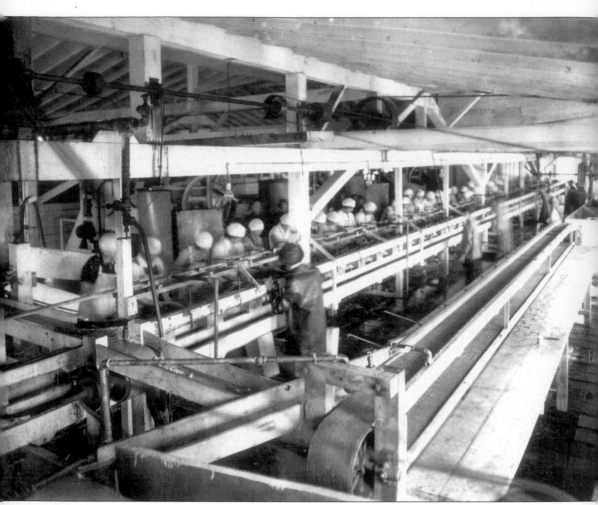

Fish were gutted and prepared for canning in the "slimehouse." The women performed their task meticulously, dressing the fish on clean wood cutting boards. Water ran continuously over the fish, the cutting boards, and the women's hands. In the packing area, work conditions were considerably better. Teenage girls would feed cans to lady workers who packed the fish into the can. Since the work of the teenagers consisted of only working with clean cans, they would wear pretty silk dresses like they were heading to a party instead of work. According to Wini Joncich Mardesich, the girls were so fast in their work that they had plenty of time to lollygag, look out the window, and flirt with the young men working outside. After cans were filled, they were passed down a center inspection table. Prior to the capping process, a machine man passed ultimate judgment, checking every tin to make sure there were no protruding bones or anything else that might prevent the can from sealing properly. (Courtesy Margaret Riddle from the Everett Library Archives.)

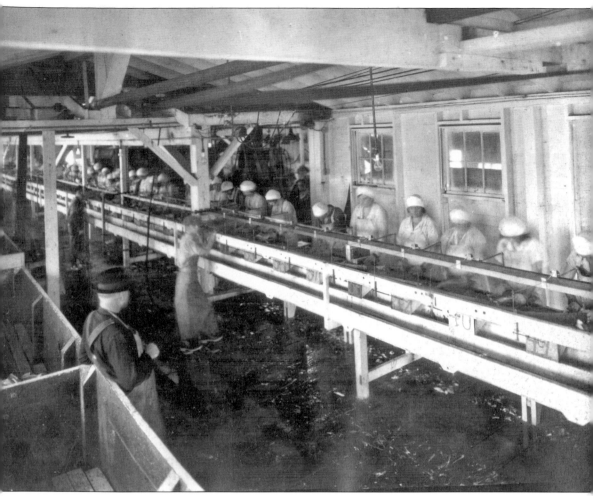

The inside of the cannery was painted entirely in white enamel. Although the covering had a gloss and hardness almost comparable to glass, the white surface showed the slightest stain. At the end of each workday, men scrubbed the walls with brushes dipped in lye water. Others busied themselves with brooms and scrapers. A high-pressure hose was manned to complete the "scrubbing down," leaving the processing rooms completely sanitized. Labeling of the cans was done entirely by machine in a different room. Several crews of women and girls worked in this department. Two women took the cans from the discharge tray of the labeling machine and dropped the cans into a case as fast as they reached their hands. One to two tons of labels were kept constantly on hand, stored in cabinets where packages of each sort and size were neatly stacked. (Courtesy Margaret Riddle from the Everett Library Archives.)

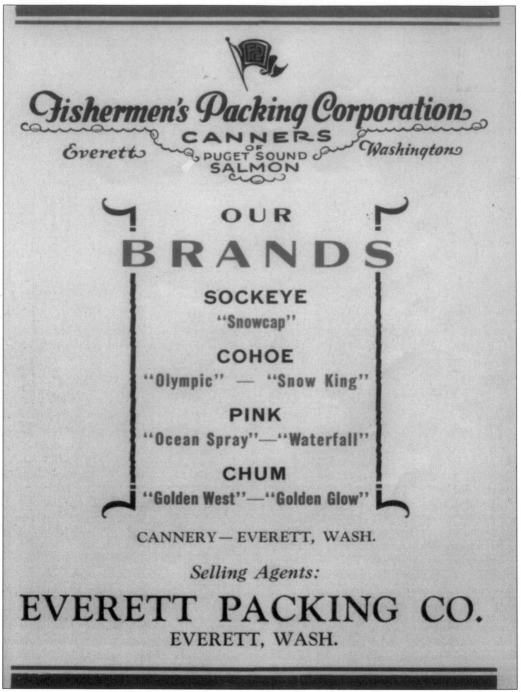

Fishermen's Packing Corporation

CANNERS OF PUGET SOUND SALMON

Everett — Washington

OUR BRANDS

SOCKEYE
"Snowcap"

COHOE
"Olympic" — "Snow King"

PINK
"Ocean Spray"—"Waterfall"

CHUM
"Golden West"—"Golden Glow"

CANNERY — EVERETT, WASH.

Selling Agents:

EVERETT PACKING CO.
EVERETT, WASH.

Originally, there were 22 captain members of the Fisherman's Packing Corporation. By 1931, more than 80 captains belonged to the company. The gain in membership quickly increased the total value of the cannery to more than $250,000, allowing the facility to quadruple in size and production. A pledge was made to accept every single fish that its members caught. An early advertisement for the Fishermen's Packing Corporation depicts its salmon label brands. Labeling of the cans was done entirely by machine. (Courtesy Cheryl Ann Healey.)

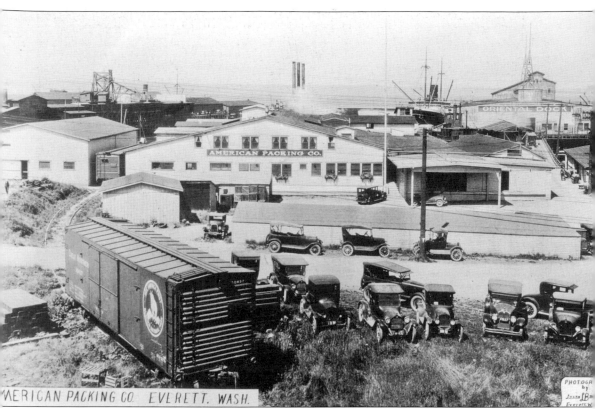

A scene from the old Everett waterfront includes the Chase family's American Packing Company and the Oriental Dock. Also shown are ships loading or unloading, railroad cars, and many early-1920s automobiles. Businesses that provided gear and support services for the maintenance of the fishing vessels were located in and around the Port of Everett. Local grocers and meat markets, including Ransick's Market, Berry's Meat Market, and Hausmann's Meat, furnished the boats with stores of food sufficient for long months at sea. Lloyd's Hardware provided a selection of hardware necessary for the repairs and maintenance of the boats. Because no doctors were aboard the boats at sea, fishermen became their own medical personnel, and penicillin and other medical supplies were also purchased and placed onboard. (Courtesy Ed and Betty Morrow.)

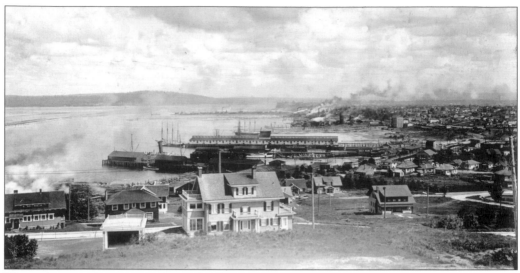

The early-1900s Everett waterfront already shows a booming business. Rapid business growth and the increasing need for imports and exports brought about the creation of the Port of Everett in 1918. Today Everett is home to the largest marina on the West Coast, with 2,050 slips. (Courtesy Historic Port of Everett.)

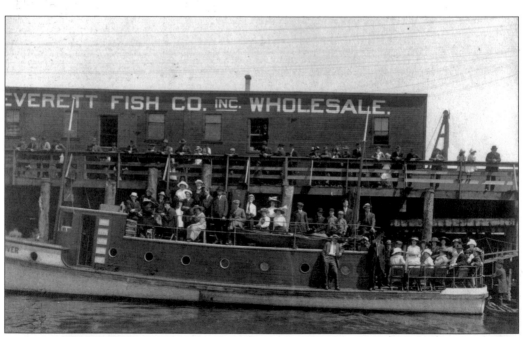

A group dressed in finery enjoys a day of sunshine and saltwater. (Courtesy Snohomish County History Museum.)

Seven

THE MEN

Until the 1930s, skiffs were rowed by hand. John Bakalich (center), a strong skiff man, was known for his immense arm muscles. Before working on the *Freeland*, John was a paratrooper in World War II. To the right is Paul Martinis, son of Matt Martinis. After World War II, he immigrated to the United States to join family in the fishing industry. He later acquired his own boat, the *DO-RO*. (Courtesy Barbara Martinis Piercey.)

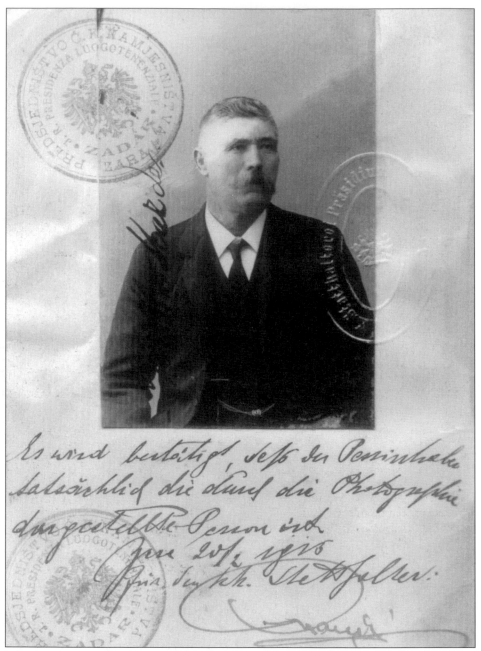

This passport was issued to Vincent P. Mardesich, an Austrian citizen from the island of Vis in the community of Komisa. He evidently traveled between Europe and the United States prior to his 1917 naturalization. Vincent came to the Columbia River by 1893 and gillnetted for canneries on both the Washington and Oregon sides of the river. Around 1902, after earning enough money in the fishing business, Vincent brought his wife, Katé, to Clifton, Oregon, a remote fishing village. Their three children, Peter, Lucrija (Lucille), and Mitch, were all born in Clifton. Years later, when signing his naturalization papers, Vincent signed his name as Wilson Mardesich. Because he was so proud to be a United States citizen, he temporarily went by the name Wilson in honor of Pres. Woodrow Wilson. (Courtesy Cheryl Ann Healey.)

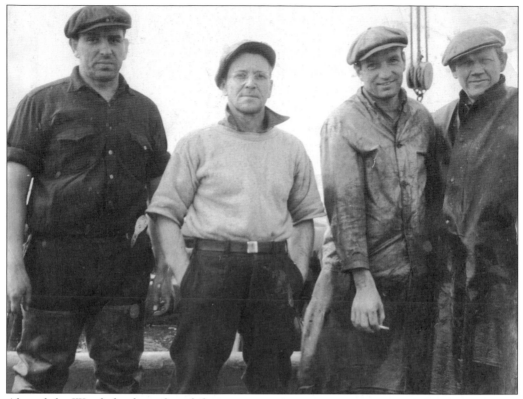

Aboard the *Wonderland* are, from left to right, Andrew Marincovich, Dick Bloskovich, Capt. Matt Marincovich, and an unidentified crew member. Both Andrew and Matt gillnetted with their father on the treacherous waters of the Columbia River before moving to the Washington coast to take on fishing in the Pacific. (Courtesy Katy Marincovich Brekke.)

A young John "Pooch" Borovina and an unidentified crew member stand aboard a boat readied for seining. John Jr. began a long career with Whitney Fidalgo Seafoods while working on the *Betty June*, the *Cypress*, the *St. Francis*, and the *Star of the Sea*. (Courtesy Jon and Susan Borovina.)

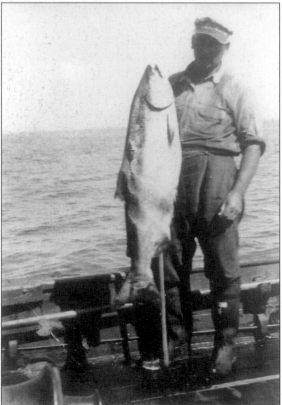

"Strong Chuck" looks across the Pacific's waters while aboard the *Wisconsin*. This quiet time is well earned but often short-lived. A sighting of fish will bring about a flurry of activity onboard with each member of the crew performing his role in a fluid, self-assured manner. (Courtesy Richard C. Wright.)

Antone Nelson immigrated to the United States from Namsos, Norway, in 1904. He and his family lived on a stump farm in Mount Vernon, Washington, milking several cows during the year. Antone fished summers with the Leese brothers until his death in 1944. (Courtesy Erv and Frauna Hoglund.)

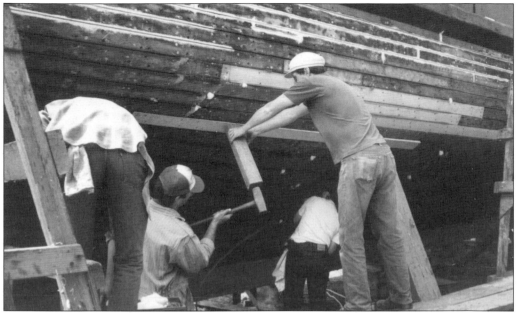

Several Barhanovich family members and friends assist the Port Townsend Boatworks staff in replanking and recaulking the *Emancipator*. After more than 70 years in service, the *Emancipator*, built in 1914, truly deserves this beautiful face-lift. (Courtesy Margaret Barhanovich and family.)

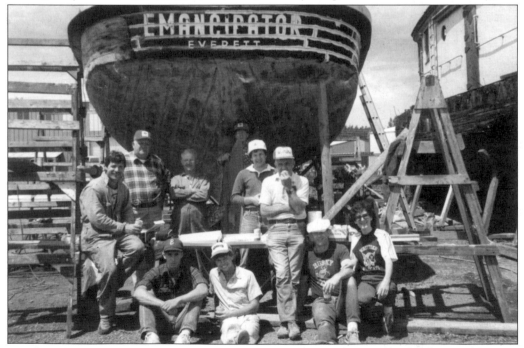

Family and friends take a break from their work on the *Emancipator* at Port Townsend Boatworks. The repaired wooden hull is now set to face another season of fishing. Pictured are, from left to right, (first row) Vince Ivelia, Tim ?, Ray Sievers, and Mary Barhanovich Sievers; (second row) skipper Jerry Barhanovich, Nick Barhanovich, Lloyd Oczkewicz, Jim King, and Orlo Ostergaard. (Courtesy Margaret Barhanovich and family.)

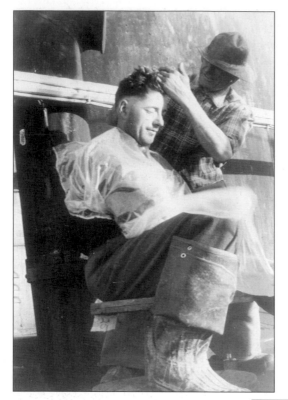

Barbers are hard to come by on the open sea. In 1951, Nick Milatich gives August (Augie) Mardesich a haircut aboard the freezer ship *North Star* in Bristol Bay, Alaska. (Courtesy Jan Zuanich from the collection of Dr. Joseph Mardesich.)

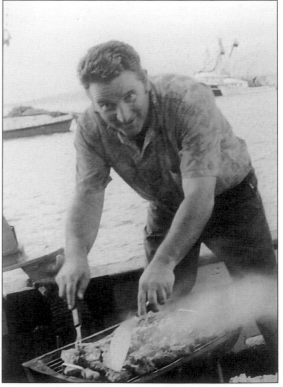

An unidentified crewman skillfully prepares a meal on an outdoor grill for the crew of the *DO-RO*. (Courtesy Stephanie Martinis Jones.)

Three crewmen and one towel make for quite the photograph! The fishermen did their best to enjoy a traditional bath while aboard their fishing vessels. At times, a few fishermen would visit a natural hot springs located in Port Moller, Alaska. The fisherman in the middle of this 1940s photograph is identified as Pete Padovan. (Courtesy Kathy Padovan Wilson and Patricia Lee Padovan Myers.)

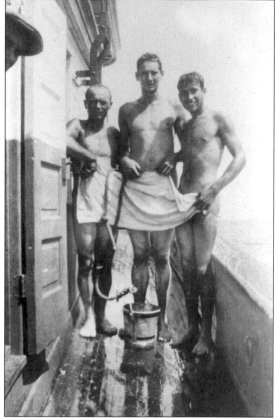

Joe Mardesich enjoys a moment of relaxation while aboard the *Silverland* in 1951. Look closely to spot his version of a pillow—a long, rubber boot. (Courtesy Jan Zuanich from the collection of Dr. Joseph Mardesich.)

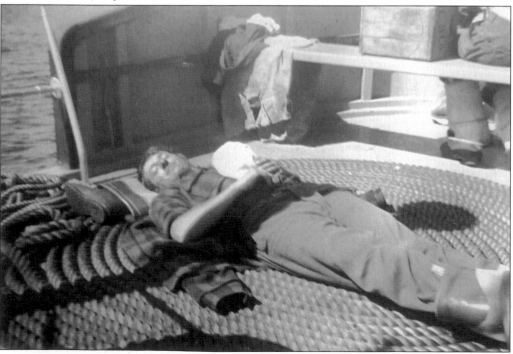

"The Crab King" Jack Moskovita reigns over his backyard collection of fishing gear. His boat is, of course, his throne. Jack would repair and fine-tune his collection of tools, engines, and boat parts, later selling them to fellow fishermen. (Courtesy Richard C. Wright.)

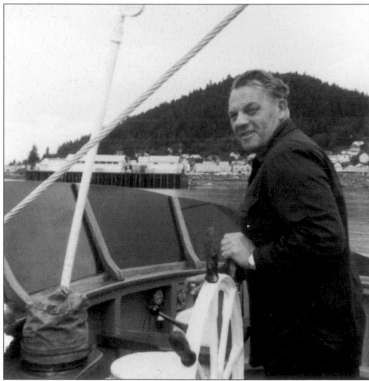

John "Pooch" Borovina, skipper of the *Star of the Sea*, married Winona "Shirley" Searles. Together they raised five children: Ross, Tam, Jon "Jay," Tony, and Marea. Stepson Ross fished with Pooch for years and currently owns and operates the *Christian S* in southeast Alaska. Jay also fishes in Alaskan waters. Tam and Tony fished with their father for a time as well. (Courtesy Jon and Susan Borovina.)

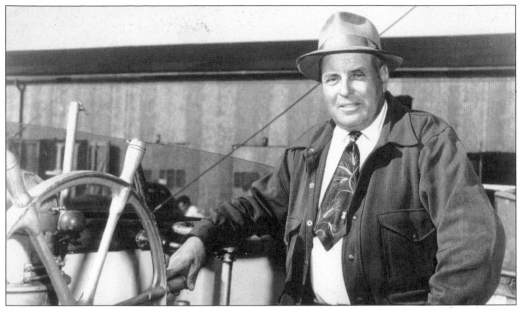

Proud owner of the two *Cheryl Anns*, John Marincovich was born in Komisa, Yugoslavia. In 1904, at the age of seven, John and his mother immigrated to Clifton, Oregon. John gillnetted on the Columbia River for over 30 years before moving to Everett where he owned the Everett Boat House and worked as a rigger during World War II. John's "good luck" fishing tie was his trademark for many years. (Courtesy Cheryl Ann Healey.)

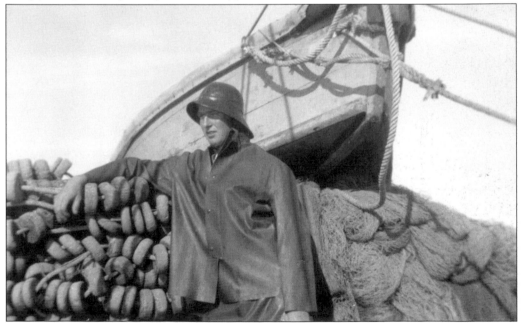

Bob Wright, born in Bemidji, Minnesota, in 1921, captained a number of gillnetters and the processor *Double Q*. Though he did not own the *North Star*, he was the last captain of this vessel, which was once used by the famous polar explorer Adm. Richard Byrd. Bob was part of the Fourteenth Street activities for 60 plus years, often exchanging tales with his good friends Augie Mardesich and George Schindler. (Courtesy Nancy Juntwait and Rob Wright.)

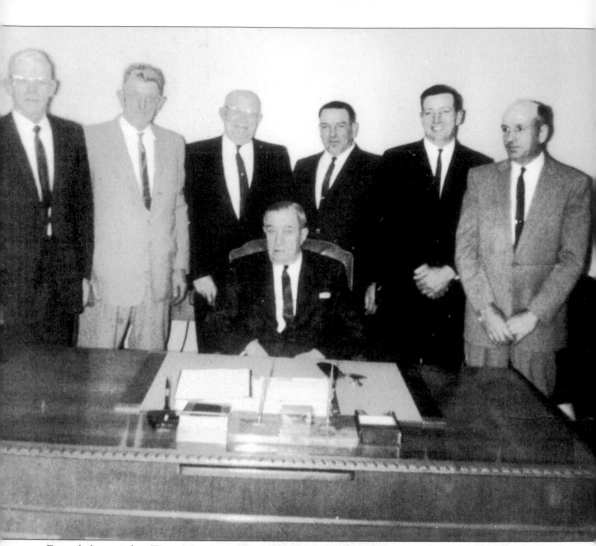

From left to right, Tony Martinis, Matt Martinis, Paul Martinis, Andrew Marincovich, Paul Martinis Jr., Matt Marincovich, and Nick Bez (seated) hold a meeting for the Fisherman's Packing Corporation. Two members had noteworthy interactions with American presidents. Fisherman Nick Bez snagged the attention of the nation when he rowed Pres. Harry Truman around Tacoma Harbor in a small boat. President Truman caught and landed a good-sized salmon (which one of Bez's associates had put on the end of the line.) A newsreel portrayed this scene around the country. Dwight D. Eisenhower paid tribute to Paul Martinis Sr. through a Western Union telegram. President Eisenhower wrote, "As you prepare to head northward for another season of fishing, I would like to join your fellow citizens who are honoring you with 'Paul Martinis Night.' In many respects your life has been truly a typical American story. I am always glad to hear of the success of persons like yourself who have come to this nation from other countries, reared a family, worked hard, prospered and participated actively in their community's affairs." (Courtesy Katy Brekke.)

Skipper-to-be Vince "Butch" Barcott stands aboard the *Cypress* in 1963. Dressed in his rain gear, he is ready to take on the commands of his uncle, Capt. John "Pooch" Borovina. Butch's "modern" rain gear is a far cry from its predecessor. The "skirtzola" of earlier times was made of stiff oil skin in the form of a bib apron with a full skirt. (Courtesy Butch Barcott.)

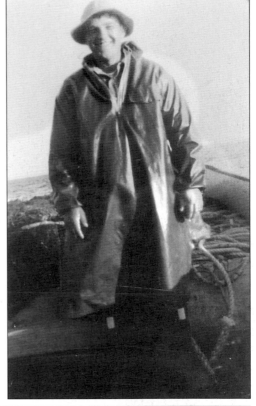

This 1993 photograph shows Nick Barcott, the last of the Barcott family to take on commercial fishing. As skipper of the *Elk*, Nick proudly carried on his family's heritage of fishing, following in the footsteps of his father, Butch Barcott, and his grandfather Vince Barcott. (Courtesy Vince "Butch" Barcott.)

Frank Zuanich is pictured in the wheelhouse of the *Wisconsin*. Frank, his brother Andrew, and his father, Anton, purchased the purse seiner *Grizzly* in 1940. In later years, the trio also purchased the *Freddy II* and the *Rhode Island*. In 1945, they built the *Voyager*, which was used for purse seining and bottom fishing, and functioned as a tender, buying fish from other boats. (Courtesy Frank Zuanich.)

Capt. Matt Marincovich and engineer Andy Mardesich work aboard the *Wonderland* in August 1958. Matt's birthplace of Clifton, Oregon, was once a hamlet of fisher immigrants from Yugoslavia, Greece, and Italy. As engineer of the *Wonderland*, Andy was responsible for the maintenance of the engine. Andy received training in Bellingham, Washington, and was one of the most respected engineers in the industry. (Courtesy Katy Marincovich Brekke.)

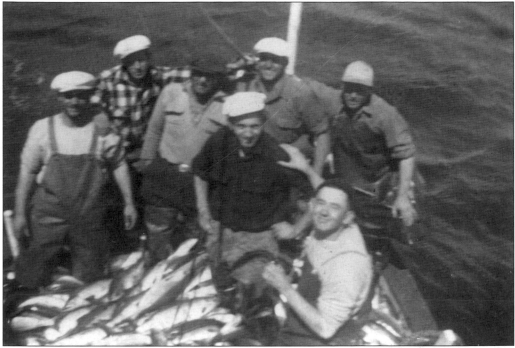

The crew of the *Iceland* poses for a photograph near Unimak Island, Alaska, in 1950. Unimak Island is the largest island in the Aleutian chain. Crewmen often became close friends while making the 8- to 10-day trip from Puget Sound to Alaska. Pictured are, from left to right, (first row) Ivo Martinis and Matt Zuanich; (second row) Sam Vitalich, Louie Padovan, Matt Martinis, unidentified, and Sam Uglesich. (Courtesy Matt and Kay Zuanich.)

Aboard the *Silverland* in 1951, Joe Matich, Lou Zuanich, and Joe Mardesich find a variety of seats while waiting for the excitement of the catch to take place. (Courtesy Jan Zuanich from the collection of Dr. Joseph Mardesich.)

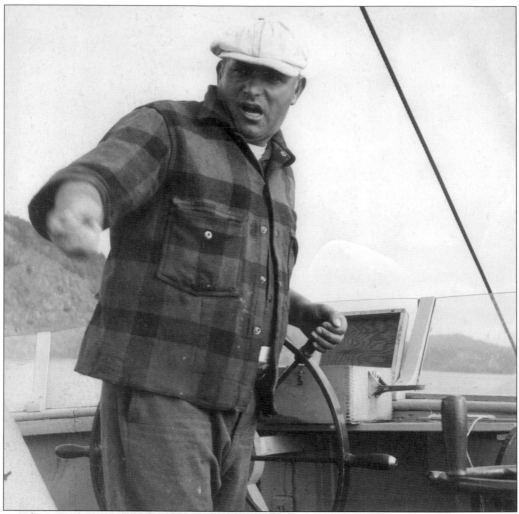

Nick Barhanovich was captain of the *Emancipator,* which was built in 1914 at the Skansie Brothers Boat Builders in Tacoma. Nick is the skipper known for his dramatic fishing catch of 14,800 sockeye salmon in September 1958. Nick also tried his hand in the sardine fishery in California for a season with the *Gladiator.* He retired from purse seining in 1986 but continued as a fish buyer until completely retiring a few years later. This photograph was taken in the 1970s. Excerpts of this information are courtesy of Lee Makovich from the article "Out of the Past" in the *Fishermen's News,* April 2003. (Courtesy Margaret Barhanovich and family.)

Eight

HOME, FAMILY, AND FRIENDS

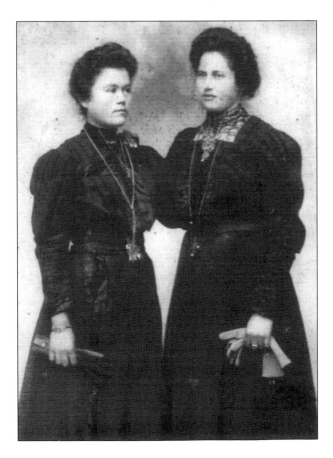

Katarina (Katé) Mardesich (left) and Ellen Mardesich were both married to early Puget Sound and Alaska fishermen. Katé's husband, Vincent "Wilson" Mardesich, and Ellen's husband, Tony Mardesich, fished out of Astoria, Oregon, as well as Bellingham and Anacortes, Washington, before settling in Everett with their families. (Courtesy Cheryl Ann Healey.)

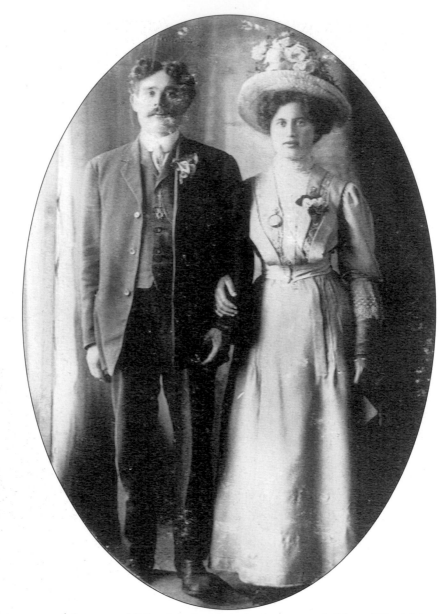

The love story of Anton and Jelica Mardesich is far from typical. Jelica (Ellen) Marinkovich, born December 29, 1887, took over the family home at the age of 11 after her parents and several siblings died in the flu epidemic. Her responsibilities were great because she cared for her two younger brothers. At the age of 17, Jelica received a proposal of marriage in the mail from Anton, who was from her hometown of Komiza but had left years earlier to seek his fortune. Anton was 10 years older than Jelica, and she last remembered seeing him when she was seven or eight years old. She wrote a letter of acceptance, and they became engaged. A year later, Anton sent money for passage to the United States. Jelica left her home, intending to meet her fiancé. After Jelica's departure, a message arrived from Anton announcing his intention to back out of marriage. But Jelica never received the message. Somehow, Jelica managed to travel to Everett and meet Anton. On April 1, 1908, the two married, and an enduring love story of home, family, and dedication began. (Courtesy Barbara Martinis Piercey.)

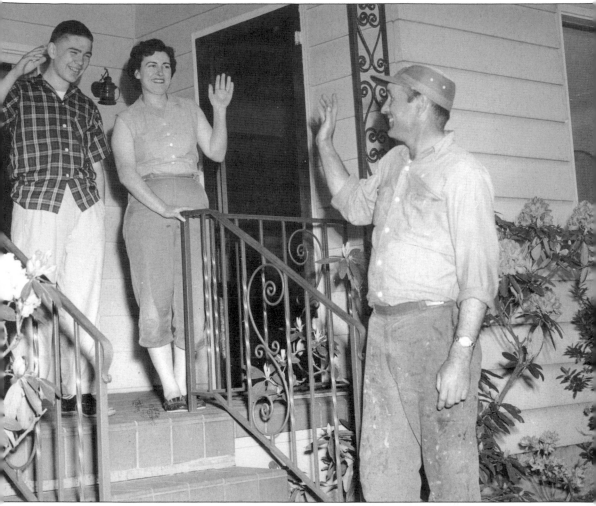

Matt Marincovich, captain of the *Wonderland*, waves farewell to his son, Andy, and wife, Pearl, as he heads to the Fourteenth Street dock to prepare his seiner for his 1957 fishing expedition to Alaska. Brought up in a fishing family, Marincovich was mending nets before he learned his ABCs. By 1957, after 24 years of fishing for salmon in Alaska, Marincovich had traveled approximately 165,000 miles, or 25 times around the world. The fishing season, which lasts for six months, includes 70 some odd days in Alaskan waters. The rest of the year, Marincovich and his counterparts busy themselves with preparation for the coming season. During her husband's long months at sea, Pearl became, quite literally, a single mother to Andy and his two sisters, Katy and Mary. (Courtesy Katy Marincovich Brekke.)

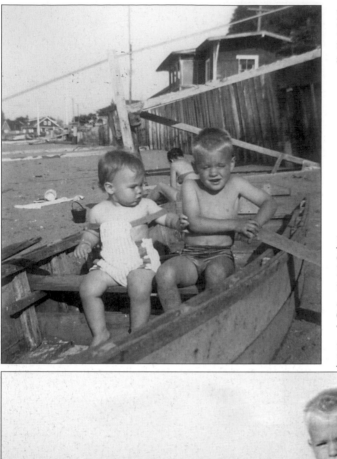

Here cousins Michael and Jon Borovina practice to be skiff men around 1957. (Courtesy Jon and Susan Borovina.)

Jon "Jay" Borovina dreamed of fishing from a young age. He now fishes two boats, the *Joe Leigh* in Bristol Bay, Alaska, and the *Susan B* in the Channel Islands of California. The *Susan B* is a light boat for the squid fishery. (Courtesy Jon and Susan Borovina.)

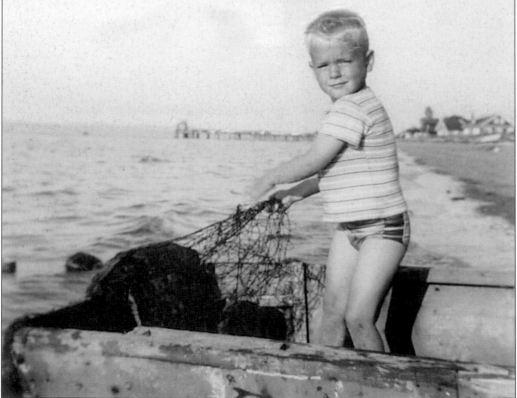

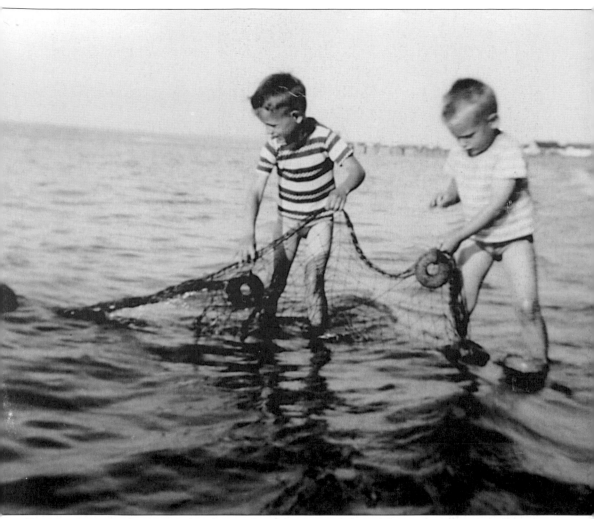

Four generations of Borovina family members have started their fishing careers at an early age. Shown pulling nets are brothers Tam and John "Jay" Borovina. Today brother Ross owns and operates the *Christian S* in southeast Alaska. Tam and his brother Tony fished for their dad for a time. Jay, who began his fishing career at age 14, began seining in southeast Alaska aboard the *Star of the Sea* with his dad, John "Pooch" Borovina. Jay broke into gillnetting in 1973. The fourth generation of Borovina fishermen includes Joe, Jay's only son, who is a primary deckhand on the *Joe Leigh*. Family member Dan Borovina also crews on the *Joe Leigh*, while his brother Matt fishes with Michael Borovina in southeast Alaska. The patriarch of the Borovina dynasty, John "Patches" Michael Borovina Sr., came to Washington from the Island of Kocula in the old country of Yugoslavia. (Courtesy Jon and Susan Borovina.)

Olga Olsen was visiting with friends Myrty and Joe Dunlap in Seattle when this photograph was taken in the late 1920s. Olga wrote on the back of the photograph, "Myrty and Joe Dunlap—we became friends working in the big fish cannery in Everett. The years were 1925 or 1926. We had many good times with them." (Courtesy Norma Greig.)

Andy "Muzzy" Zuanich (right); his wife, Dorothy; and two crew members enjoy a trip aboard the *Voyager*. Andy and Dorothy often took the boat out on picnics, family excursions, and trips with the Knights of Columbus. (Courtesy Richard C. Wright.)

Another unit to Everett's ever-increasing fishing fleet was added when the purse seiner *Cheryl Ann* dipped its keel into the waters of Puget Sound in July 1947. The craft was the first of two *Cheryl Anns* owned by John Marincovich. Built at the Carl Anderson yards, it was christened by Pearl, the youngest daughter of John and Lucille Marincovich. (Courtesy Cheryl Ann Healey.)

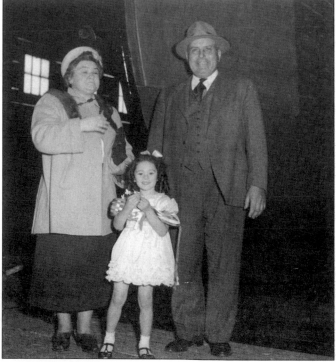

It is christening day in July 1949 for the second *Cheryl Ann* at the Howard Sagstad Boat Builders in Ballard, Washington. Enjoying the festivities of the day are John Marincovich, owner; his wife, Lucille Mardesich Marincovich; and his granddaughter Cheryl Ann Wilson. (Courtesy Cheryl Ann Healey.)

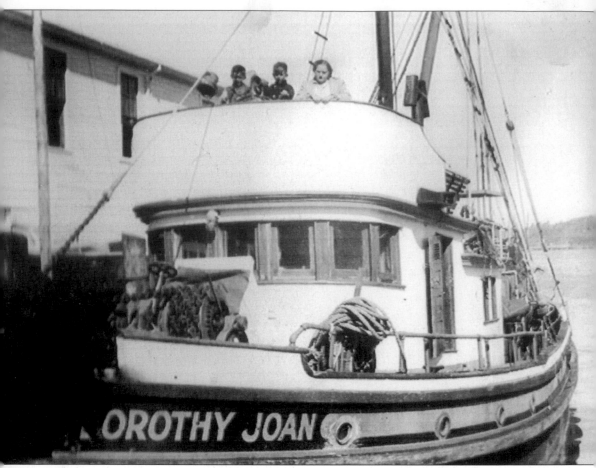

Aboard the pilothouse of the *Dorothy Joan* are, from left to right, Marty Petrucela, Anton Mardesich, and Helen Mardesich. The photograph captures this fishing family's day at the dock. Unfortunately, the *Dorothy Joan* would later travel to a swift moment of heartbreak. On September 13, 1945, the purse seiner fell victim to the sea off Yaquina Bay, Oregon. Pete and John Mardesich, owners of the *Dorothy Joan*; Frank Bakalich; Vince Demondich; and a man known as Eric all succumbed to the salty waters. When the boat capsized, survivor William Henry (Hank) Weborg had no visuals of Pete or John. For a time, Hank and the other crew members held onto a skiff that had detached from the seiner. Eventually, Hank was the only one left hanging onto the skiff in the rough, frigid water. When he was found some four or five hours later, Hank was bleeding from head to foot. He spent several days recuperating from the shock and exposure he suffered. (Courtesy Toni Joncich Mardesich.)

Mike "Pepe" Borovina and his wife, Alice, enjoy time aboard the *Emblem* in 1953. Mike took over the *Emblem* from his father, John Sr., in 1942 after fishing with Paul Martinis Sr. on the *Dreamland* for a period of time. (Courtesy Jon and Susan Borovina.)

"The Crab King" Jack Moskovita and his wife, Louise, spend time aboard their crab boat somewhere around Port Susan in Washington State. Often, Louise worked side by side with her husband, baiting and checking traps. (Courtesy Richard C. Wright.)

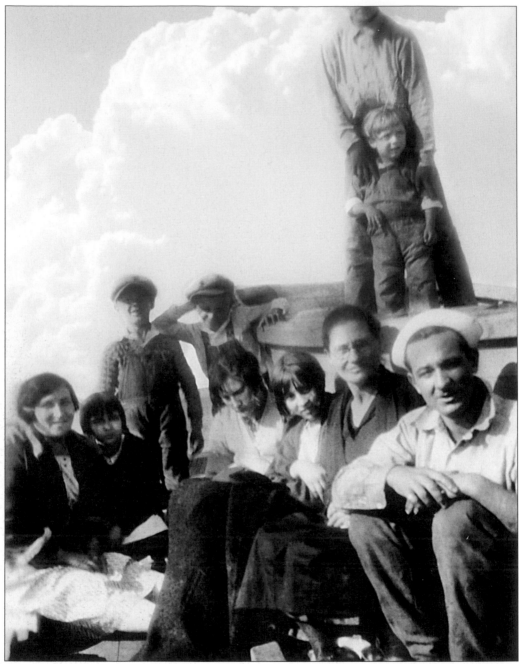

The Joncich family enjoys a picnic in 1927. It was common practice to take family and friends on the fishing boats for a day of picnics and fun. During strawberry season, a boatload of families would head for Whidbey Island to visit the large berry farms. The boats would anchor, and then family members would get in the skiff and be ferried to the beach. Berries were picked so the women could make jams and jellies. Pictured are, from left to right, (first row) Maria Lubetich Joncich, Minnie Joncich, unidentified, Wini Joncich, Aneta (Ana Stanojovic) Felando, and Vince Felando; (second row) Augie Mardesich and Tony Mardesich; (third row) Johnny Joncich holding Joseph Mardesich. (Courtesy Wini Joncich Mardesich.)

Nine

THE BOATS

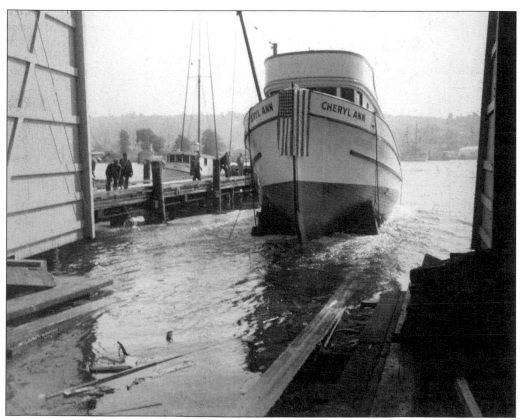

The Everett fishing fleet is joined by a newcomer, the *Cheryl Ann*. The seiner, the second to be called *Cheryl Ann* by owner John Marincovich, was built in Ballard, Washington, in July 1949. Its predecessor was sold in the fall of 1948. As one of the most polished boats in the fleet, she is fully ready for the upcoming salmon season. (Courtesy Cheryl Ann Healey.)

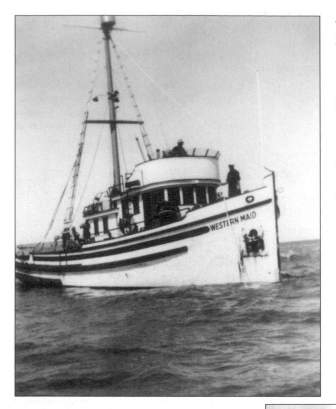

The 76-foot purse seiner *Western Maid* was built in Tacoma in 1934 by Western Boat Builders. In 1944, brothers Tony and John Mirosevich and Nick Mardesich Sr. purchased the boat and brought it to Everett to catch dogfish (livers from the dogfish were rendered down to make light machine oil.) Tony eventually bought out his partners and fished in Alaskan waters and off the Washington coast. (Courtesy Susan Mirosevich Bahl.)

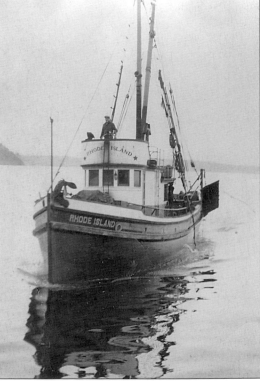

Andy Zuanich stands at the helm of the purse seiner *Rhode Island* in 1942–1943. The *Rhode Island* was one of four purse seiners owned by Zuanich family members. During the 1960s, Andy and his brother Frank would show off their seiner, the *Voyager*, at the Salty Sea Days celebrations on the Everett waterfront. (Courtesy Frank Zuanich.)

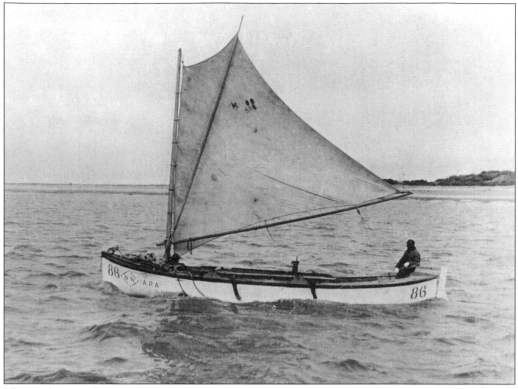

This early Bristol Bay sail gillnetter was a Bumble Bee cannery boat, seen here in this photograph around 1948. (Courtesy Phil Cunningham.)

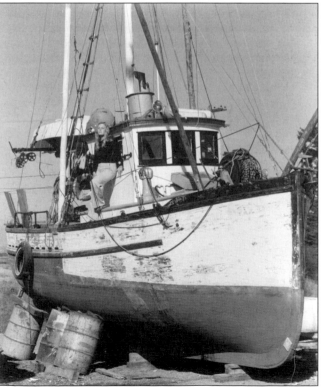

Carol Peterson, wife of Ted Peterson, poses on their troller out of Everett. They trolled off the Washington coast out of Neah Bay and other ports on the coast. (Courtesy Richard C. Wright.)

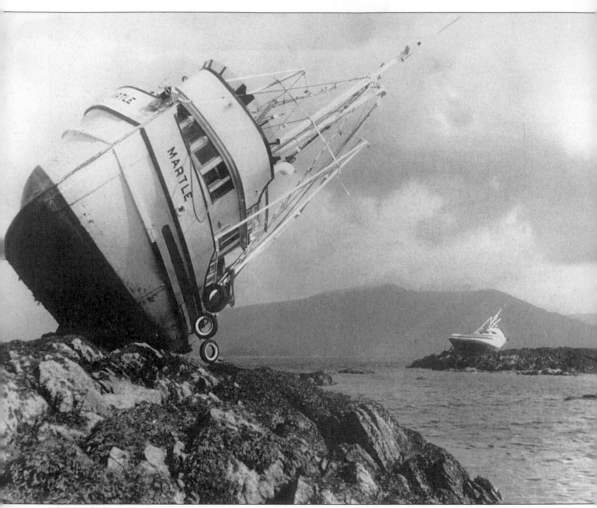

John "Pooch" Borovina was a witness to the grounding of the *Martle* and the *Cypress* near Ketchikan, Alaska. He left a detailed description of the scene in this message: "Left Ketchikan 12:30 a.m., August 21, 1963. Following the *Carl R* and the *Martle*. We were the last boat. We were heading south at around 2:30 a.m. when the man on watch stopped the boat and woke me and told me the *Martle* was on the rocks. We started to launch our skiff, then the boat drifted against a rock. I backed up full speed. The boat laid over to the starboard side and was aground. We tried to launch our skiff, but it came inboard. The boats *Haida Boy* and *Ann Page* came in with their power skiffs and took the *Cypress* and *Martle* crew off the rocks—foggy." Amazingly, both the *Martle* and the *Cypress* were released from the rocks during a high tide and with some assistance from other seiners. (Courtesy Susie and Jon Borovina.)

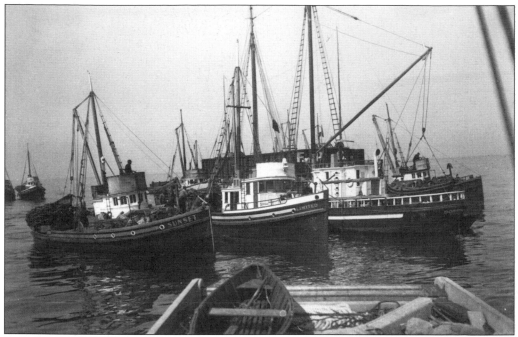

In the early 1930s, seiners *Sunset*, *Limited*, and *Dorothy* approach the Fisherman's Packing Company tender, the seiner *Elector*, captained by George Moskovita. Three other seiners wait in the background to discharge their catch of salmon onto the tender. Note the lack of power blocks on the seiners. Nets were still being hauled by sheer manpower. (Courtesy Jan Zuanich from the collection of Dr. Joseph Mardesich.)

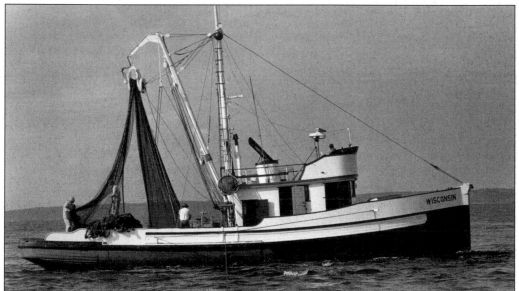

Fishing aboard the *Wisconsin* are skipper Frank Zuanich, chief engineer Merle Kindle, and skiff operator Dick Wright. Jack Moskovita is seen in the web. This group of men can attest that there is no such thing as a nine-to-five day for a fisherman. Even with the addition of motorization and push-button controls, commercial fishing continues to be a high-risk operation. (Courtesy Richard C. Wright.)

This classic Columbia River gillnetter awaits "The Crab King," Jack Moskovita, at his Everett moorage. (Courtesy Richard C. Wright.)

The camera captures a peaceful scene of "The Crab King's" boat on a cold winter's evening. (Courtesy Richard C. Wright.)

The *Mermaid II* stands at dry-dock in Everett in the early 1930s. Wilhelm Leese purchased the *Mermaid II* in 1926 from Martin Ancich and Lee Makovich Sr. Wilhelm fished the Puget Sound until his retirement in 1960. His son William purchased the boat and fished with it in Alaska and Puget Sound until 1976. The *Mermaid II* is now in Alaska. (Courtesy Bill and Charlene Leese.)

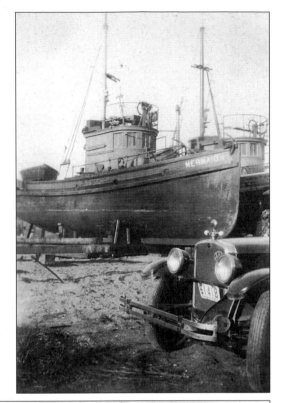

The Leese brothers fished Point Roberts until their retirement. This 1940s photograph shows the *Mermaid II*, owned by Wilhelm; the *Montague*, owned by Walter; the *Solta*, owned by Emil; and the *Sunset*, owned by Albert. Family members eventually acquired the boats: the *Solta* by Emil's sons Jim, Richard, and Dennis; the *Montague* by Walt's son-in-law Harold Halvorson; and the *Mermaid II* by William O. Leese. (Courtesy Bill and Charlene Leese.)

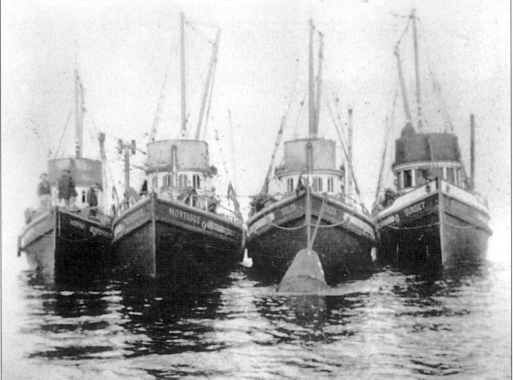

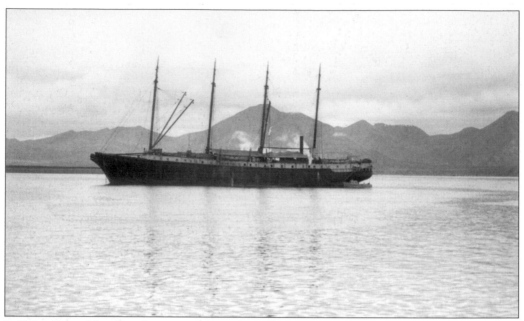

La Merced, an old sailing ship, was converted to a floating cannery. She served the Everett fishing fleet for a number of years in Alaskan waters. The sailing vessel was converted to diesel, and the spar of the ship was removed in the 1940s. (Courtesy Stephanie Martinis Jones.)

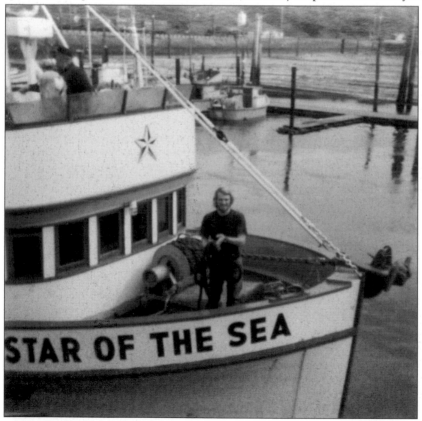

Jon "Jay" Borovina crewed with his father aboard the *Star of the Sea* before running his own two boats, the gillnetter *Joe Leigh* and a light boat for the squid fishery, the *Susan B.* (Courtesy Jon and Susan Borovina.)

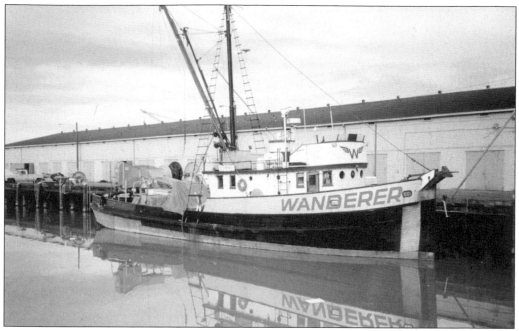

The *Wanderer* moors at Everett's Fourteenth Street dock in recent years. When sails and oars were the chief motive power of fishing boats, most seining was done along the beaches of Puget Sound and adjacent waters. As boats turned to diesel power, operations traveled as far as the Aleutian Islands, with the trip from Everett to False Pass, Alaska, generally taking eight to nine days. (Courtesy Stephanie Martinis Jones.)

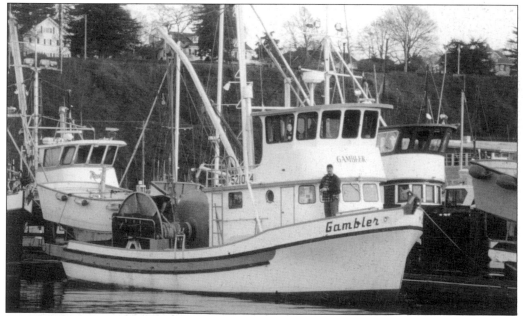

Skipper Don McGhee Sr. built the *Gambler* in the winter of 1969. The gillnetter, which he built himself, took eight months to complete. Don was ready to fish by the summer of 1970. This photograph, taken in 2000, shows Don McGhee Jr. standing on the deck at the Fourteenth Street gillnetter moorage. (Courtesy Janice McGhee.)

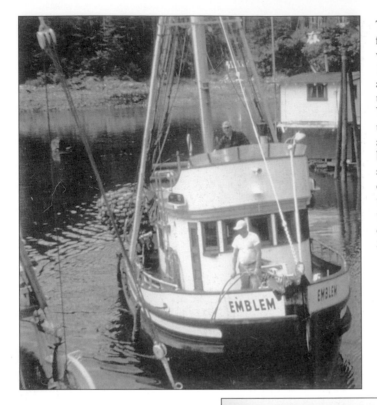

The *Emblem*, the Borovina family's primary fishing vessel, is underway in 1959. Fishermen such as the Borovinas know that traveling between Washington's coast and the icy straits of Alaska on a fair, sun-kissed day can be exhilarating. But on a stormy day with oppressing clouds lying on the water, travelers seem to journey through a lost and empty country. (Courtesy Jon and Susan Borovina.)

The *Polarland* was built in 1942 by the Harold Hansen Boat Company in Seattle, Washington, for Vince Martinis. He operated this vessel from Puget Sound to the Bering Sea. After Vince passed away, Emil Leese purchased the *Polarland*; he had always admired it. The purchase became a short-lived dream come true. Emil operated the boat for only one season before he passed away in 1954. (Courtesy Jim and Juanita Leese.)

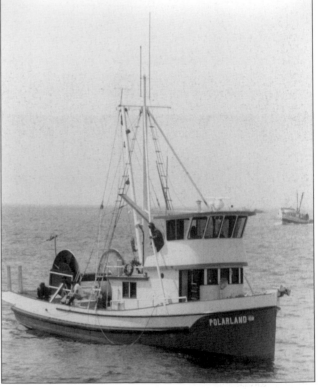

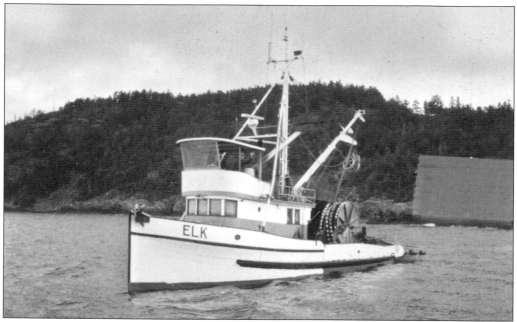

Seen here during fall fishing off Possession Point, the *Elk* is owned by Butch Barcott and skippered by his son Nick Barcott. The *Elk* is one of the oldest boats in the Everett fishing fleet, having been built in 1912. (Courtesy Butch Barcott.)

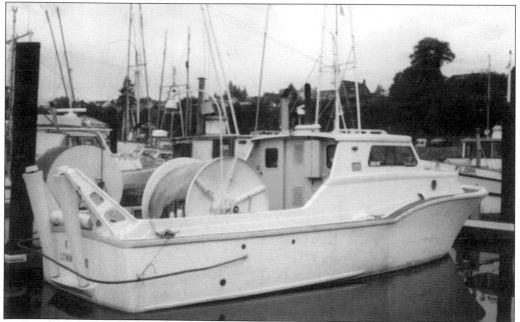

The *Kymi*, owned by Bud Thompson, moors at Everett's docks. Bud's brother-in-law Bob Gross worked as a crew member, and his wife, Dorothy Thompson, often accompanied her husband gillnetting. No stranger to Everett's waterfront, Dorothy worked at Nick Radovich's Everett Fish Company, Steve Chase's cannery in Everett, and Pan Alaska in Monroe. She worked in the canneries from high school into the 1980s, when this photograph was taken. (Courtesy Dorothy Gross Thompson.)

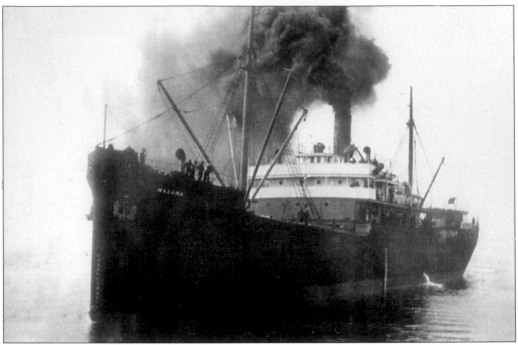

The floating cannery *Mazama*, owned by Everett Packing Company president Samuel P. McGhie, leaves for Henredon Bay, Alaska. It is set for a season of fishing and canning salmon. Also aboard were Captain Hogan and chief engineer Russell Knight. Several university students from the Everett area were part of the cannery crew. A dairy cow known as the famous "sea cow" was also on board to provide milk and cream for the crew and passengers. (Courtesy Debra Wright.)

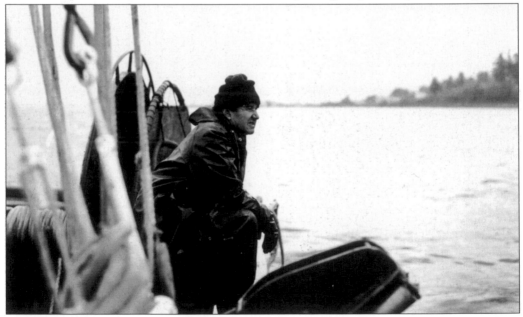

As a third-generation fisherman, Tony Martinis Jr. fished the local waters of Everett on his boat the *Blue Chip*. Tony was the last member of his family to commercially fish in Puget Sound. (Courtesy Katy Brekke.)

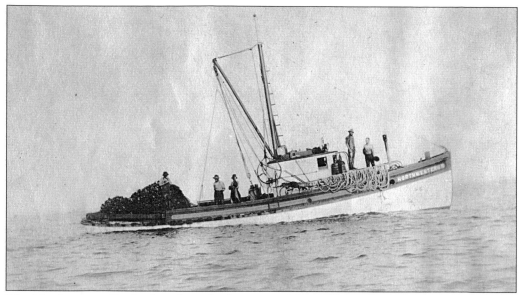

The *Northwestern II* rides low through the waters. Manned by eight or nine men, each purse seiner represents scores of industries and suppliers who outfit the boats for their fishing grounds. (Courtesy Bill and Charlene Leese.)

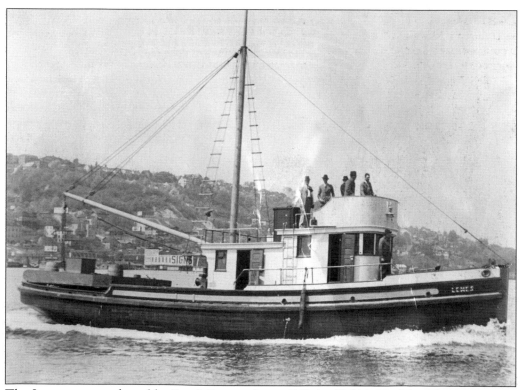

The *Lemes* was purchased by Frank Barcott Jr. in 1938 for $2,500. He fished for salmon and bottom fish throughout Puget Sound. This picture shows Frank at the helm of his new fishing vessel. (Courtesy Frana Barcott Hoglund and Erv Hoglund.)

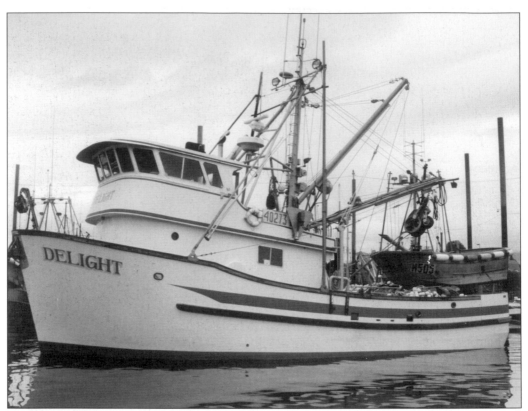

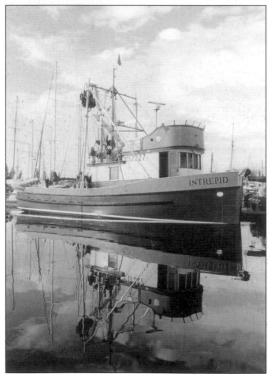

The *Delight* was purchased by William O. Leese from Wally Green. She was sold in 2006 to family members Joe and Jenny (Leese) Cisney. (Courtesy Bill and Charlene Leese.)

The *Intrepid* has stayed in the Leese family from original owner William O. Leese to daughter and son-in-law Sue and Jim Waltz. The Leese boats, including the *Sea Crest*, the *Charlene Marie*, and the *Anna Lovisa*, came to be called the "green boats" for their distinctive green paint. (Courtesy Bill and Charlene Leese.)

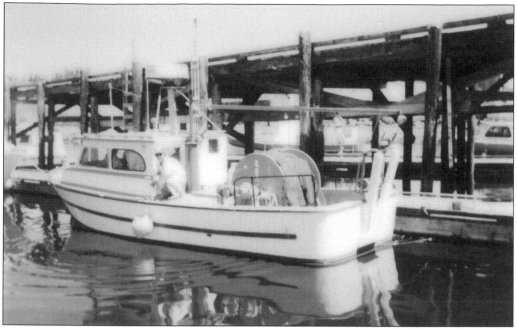

The gillnetter *Little Rich*, an Everett-based fishing vessel, is shown moored at Jackson's Cannery in Friday Harbor, Washington. Rich Jackson and Noel Gallanger of Everett shared captain responsibilities, depending on who was napping at the time. (Courtesy Jill Jackson.)

The seiner *Laurianne*, owned by Larry Brandstrom, docked in Everett from the late 1970s into the 1980s. Larry fished for the Whiz Fish Company and New England Fish. He belonged to the Seiners Association and his grandfather, uncles, and cousins all had fishing boats docked in Ballard. The *Margreet J*, the *Marietta J*, the *Patty J*, and the *Josie J* were his uncle Spud Johnson's boats. (Courtesy Betty Brandstrom.)

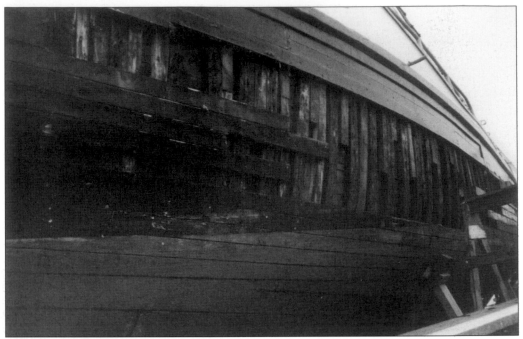

In the mid-1980s, the *Emancipator* was taken to the Port Townsend Boatworks for major repairs to the hull, including replanking and new ribs. The refastening required 8,000 galvanized nails. The boat was originally built for Paul Puratich at the Skansie Shipyard at Gig Harbor in 1918. (Courtesy Margaret Barhanovich and family.)

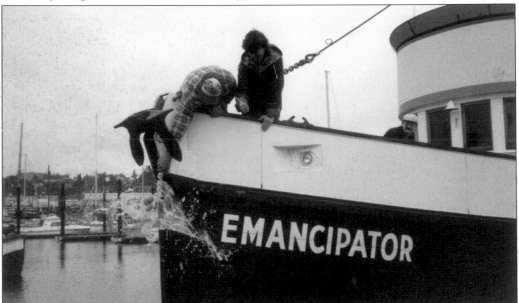

A newly refurbished *Emancipator* receives a second christening from Nick Barhanovich. The boat had served Nick well. At the end of Washington's 1958 sockeye season, when runs were few and far between, the *Emancipator* made an unexpected haul. Its net was near bursting weight with over 14,800 salmon. With the hatch and deck completely full, the *Emancipator* rode dangerously low in the water. (Courtesy Margaret Barhanovich and family.)

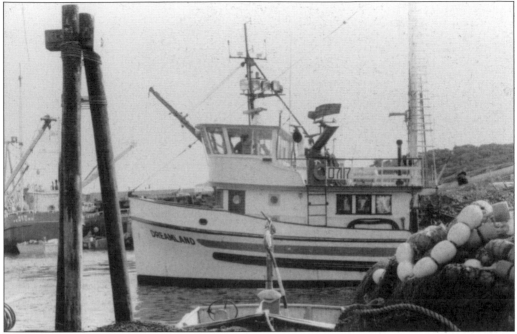

The fishing vessel *Dreamland* passes through Kodiak Island harbor on her way home from False Pass, Alaska, at the end of August 1980. The *Dreamland* was a product of the Western Boat Building Company of Tacoma. It proved to be a dreamboat for the fishing industry, equipped with the latest innovations in navigation, radio telephone, and electric refrigeration. (Courtesy Jack Rookaird.)

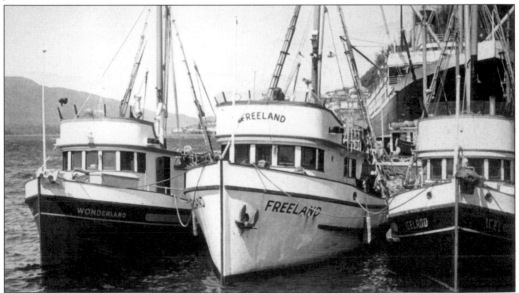

"The *Iceland*, the *Frostland, Tatoosh*, and *Silverland*. The boys are going fishing off Alaska's golden strand." This chantey sounded over Puget Sound's waters, usually in May, during the 1930s. Family and friends raised their voice in song and farewell as Everett's sizable contingent of seiners set sail for the Aleutian peninsula. In this photograph, the *Iceland* (right) is joined by the *Wonderland* and the *Freeland*. (Courtesy Stephanie Martinis Jones.)

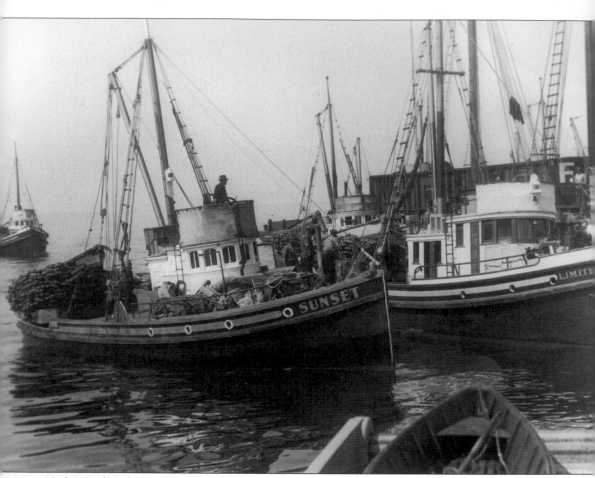

Nick Mardesich Sr. stands aboard the *Sunset* waiting to unload fish to the cannery tender. Next to it is the *Limited*, a boat based in Tacoma, Washington. The house-like structure in the background is the Fisherman's Packing Company scow anchored in the San Juan Islands. Nick owned two boats named *Sunset*. The boat pictured was eventually sold. The second *Sunset* was originally named the *Gowan*. It is this vessel that met with disaster in 1950. A radiogram from Kodiak, Alaska, advised Mary Mardesich that her husband, Nick Sr., and son Tony, a member of the Washington State Legislature, had lost their lives. An Aleutian williwaw (a sudden gust of wind) "whipped" up the seas, capsizing the purse seiner near False Pass, Alaska. Antone W. Morrovich of Seattle, Vince Vlastelica of Everett, and Frank Suryan of Anacortes also lost their lives. The seiner *Johnny B*, skippered by Joseph Lucin, rescued three of Captain Mardesich's sons—August Paul, Joseph, and Nick Jr., and a nephew, Tony Mardesich. (Courtesy Jan Zuanich from the collection of Dr. Joseph Mardesich.)

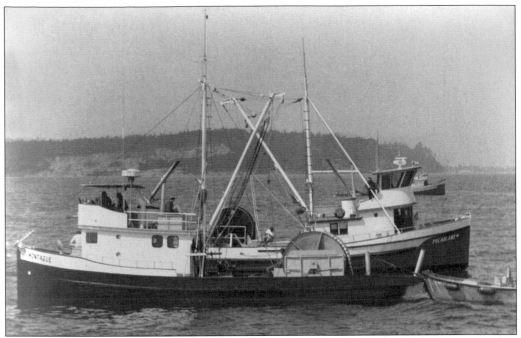

The *Polarland*, owned by Jim Leese, and the *Montague*, owned by Jim Leese Jr., fish the reef off of Point Roberts, Washington, in August 1980. The *Montague*, built in 1971 by Babare Brothers Boat Builders of Tacoma, Washington, was originally a 62-foot vessel. It was shortened to 58 feet in 1964 to comply with Alaskan regulations. (Courtesy Jim and Juanita Leese.)

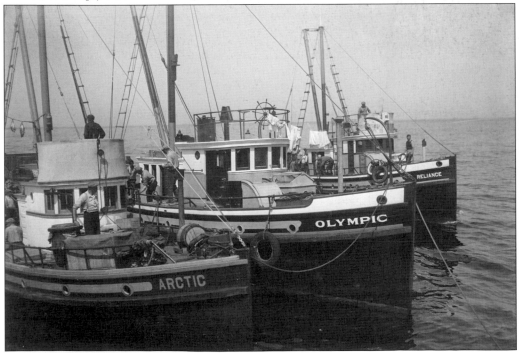

The *Arctic*, the *Olympic*, and the *Reliance* enjoy a calm day upon the waters. When the winds pick up and the water churns, the boats lie in the water, shifting back and forth on their anchors.

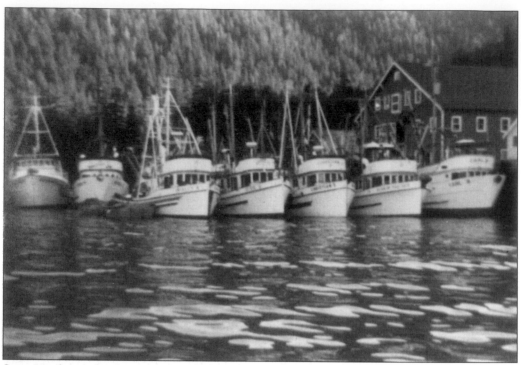

Seiners raft together at Steamboat Bay, Alaska, during the summer of 1979. There are stories of the early years in which boats would raft together at night for a time of meals, business, stories, and song. The stories and song were sometimes traditional; at times, they were written by the men. (Courtesy Jon and Susan Borovina.)

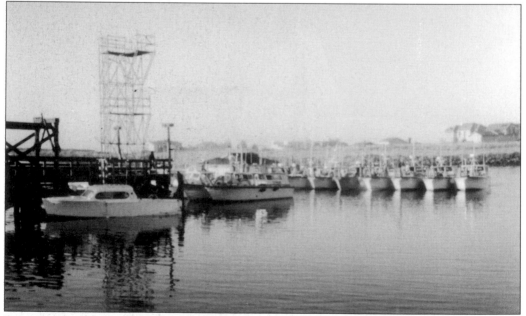

Tim Vardy's vessel and the Everett gillnet fleet stand side by side, tied one to another at Point Roberts, Washington. Tim took this photograph when he realized that his business, Sea Horse Boats, had built every bow picker in the photograph. (Courtesy Tim and Linda Vardy.)

Ten

THE FISHING INDUSTRY TODAY

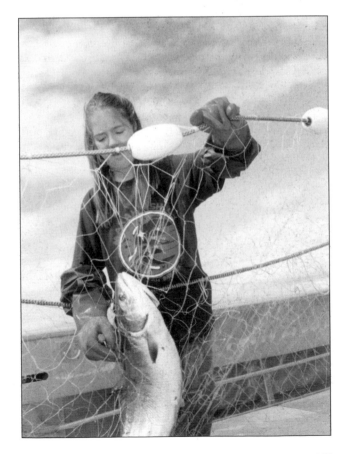

Katherine Piercey, age 16, picks fish from the gillnet of her father's vessel, the *Katherine B*, in Bristol Bay, Alaska. Katherine is the fifth generation of the Tony Mardesich family to fish in Alaskan waters. She said at the end of her first full-time season, "I can pick 'em, I can pitch 'em, and I can cook 'em!" In 2008, at the age of 23, Katherine continues to gillnet with her father, Guy Piercey. (Courtesy Guy and Gwen Piercey.)

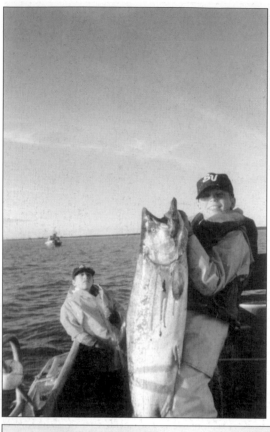

Ten-year-old Peter Ludwig, aboard the *Blue Sky*, displays a nice Bristol Bay king salmon. He and his brother Jeff seem to be enjoying this 2001 trip to Bristol Bay, Alaska. (Courtesy Joel Ludwig.)

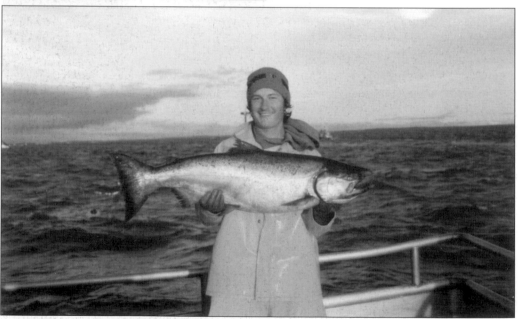

Joseph Borovina is a member of the fourth generation of Borovina fishermen. In this 2007 photograph, he shows off a beautiful salmon caught on the *Joe Leigh* in Bristol Bay, Alaska. (Courtesy Jon and Susan Borovina.)

Daniel Borovina, another fourth-generation Borovina fisherman, has found his niche working on the *Sea Pride* with his brother Matt. He also spends time sardine fishing in Astoria, Oregon, squid fishing in California, and working with Jon "Jay" Borovina on the *Joe Leigh* in Bristol Bay, Alaska. (Courtesy Jon and Susan Borovina.)

In the world of fishing, the name Borovina attaches itself to seining, gillnetting, dragging, longlining, tendering, processing, and squid fishing. If it swims, they have caught it. If it has been caught and cleaned, they have eaten it. From the Bering Sea to Mexico, the name Borovina rings clear. Pictured is Michael Borovina (right) aboard the *Sea Pride* in 1999. (Courtesy Jon and Susan Borovina.)

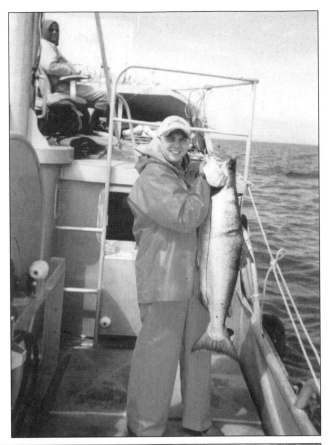

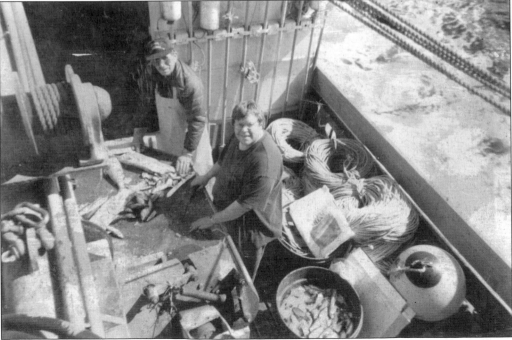

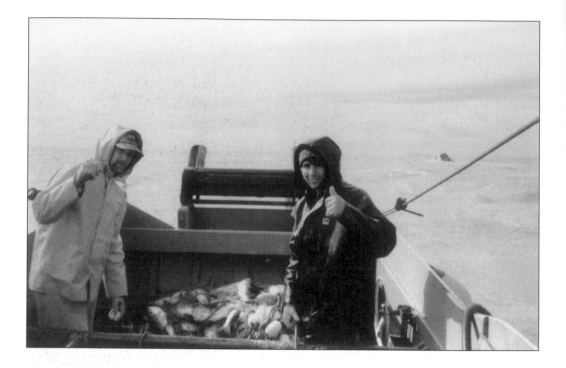

Peter Arnestad (left) and Mark Ludwig (right) crew on the fishing vessel *Stanvic* in 1983. Their "thumbs up" is a strong indication that fishing with their family makes for a good time on the water. (Both, courtesy Joel Ludwig.)

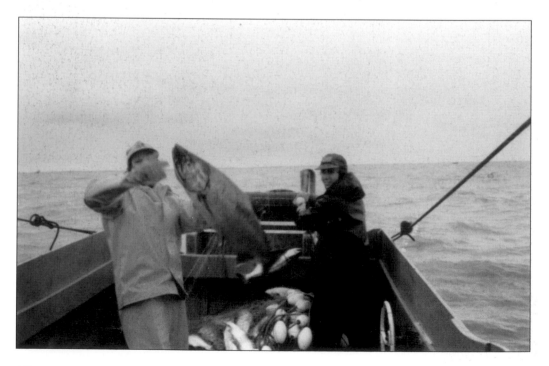

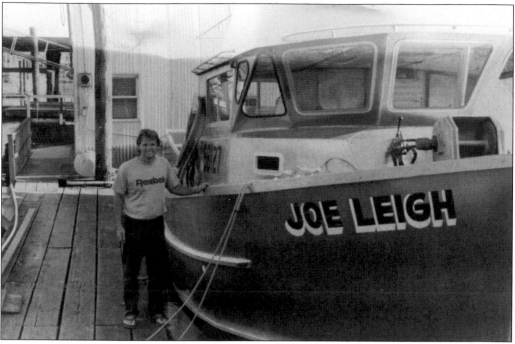

Jon "Jay" Borovina shows off his Bristol Bay gillnetter. The *Joe Leigh* is named, in part, after his son Joe, who serves as his primary deckhand. (Courtesy Jon and Susan Borovina.)

Guy Piercey spends a last day aboard the *Julia Breeze* before it is turned over to a new owner who will fish in Alaskan waters. The sale of the vessel took place in 2003. (Courtesy Barbara Martinis Piercey.)

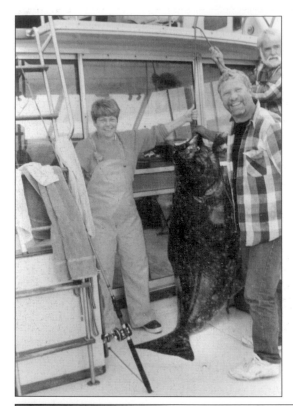

Phil Cunningham (back right) and his wife, Cora, take a break from commercial trolling in southeast Alaska. And what does a commercial fisherman do on his day off? He goes fishing, of course! On this day in 1990, the couple lands a 185-pound halibut while aboard a friend's cruiser. (Courtesy Phil Cunningham.)

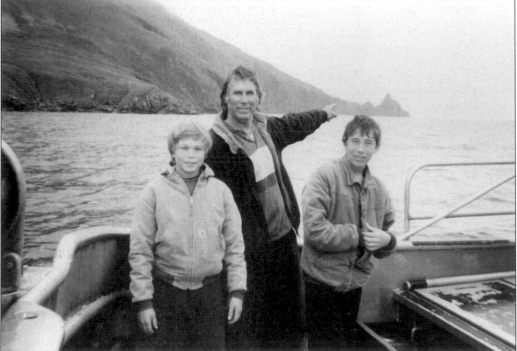

Aboard their fishing vessel *Blue Sky*, Joel Ludwig (center) and his sons Peter (left) and Jeff enjoy the scenery of Walrus Island in Bristol Bay, Alaska. (Courtesy Joel Ludwig.)

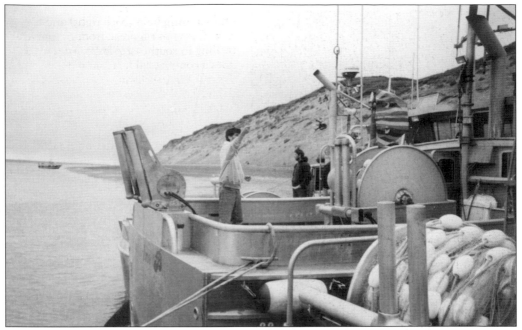

Guy Piercey stands aboard the *Katherine B.* His boat, purchased in 1983, is rafted along the shore in Bristol Bay, Alaska. On a 2008 trip to deliver a boat to Ensenada, Mexico, Guy related to his family that after a rough trip through the Strait of Juan de Fuca, he had finally entered calmer waters. That evening he was able to read a newspaper by moonlight. (Courtesy Guy and Gwen Piercey.)

When Guy Piercey purchased the *Julia Breeze*, the hull of the boat was partially built as a sail trawler. Guy finished the construction, enabling him to fish for halibut, black cod, tuna, and dogfish. The boat also spent several seasons tendering. (Courtesy Guy and Gwen Piercey.)

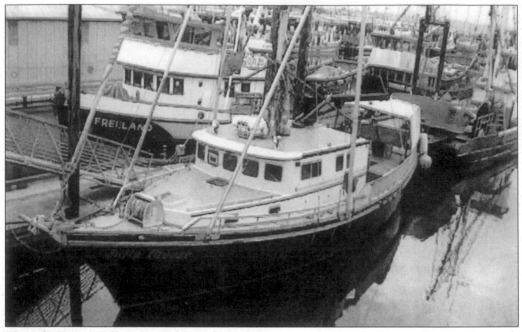

The *Julia Breeze*, fully equipped for Alaska fishery, is tied up at the Everett Marina. It stands alongside a family member's purse seiner, the *Freeland*. (Courtesy Jim and Barbara Piercey.)

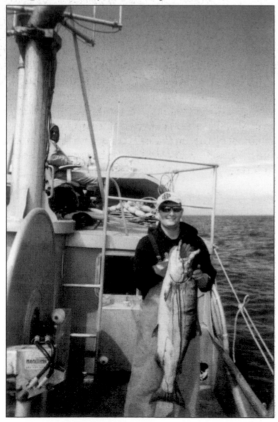

Jon "Jay" Borovina enjoys a successful day of fishing while aboard his gillnetter, the *Joe Leigh*. Bristol Bay, Alaska, continues to be a leading hub of fishing activity. In 2007, its division of commercial fisheries reported a preliminary catch of 29.5 million sockeye. About 63,000 Chinook salmon and two million chum salmon were caught in Bristol Bay during the same year. (Courtesy Jon and Susan Borovina.)

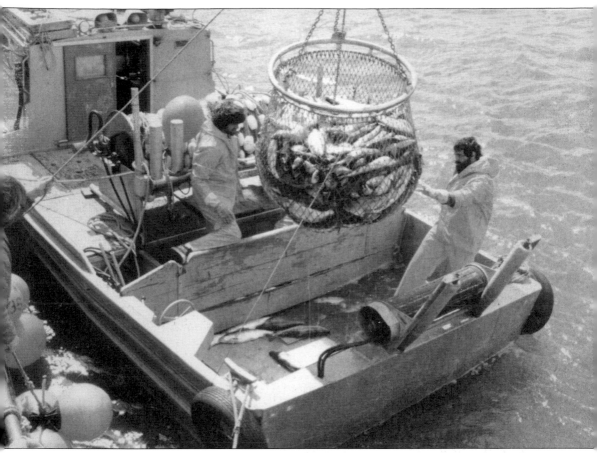

Brothers Paul and Guy Piercey transfer a brailer load of sockeye salmon to a tender in Bristol Bay, Alaska. Paul and Guy continue on with a long heritage of commercial fishing. Their family history has strung from a small island in Croatia, as well as the country of Norway, to the shores of Washington, Oregon, and Alaska. With an ancestry that includes the names Marincovich, Mardesich, Martinis, and Olsen, the Piercey men, as well as their fellow fishermen, can stand proud in continuing on with this rich legacy. (Courtesy Guy and Gwen Piercey.)

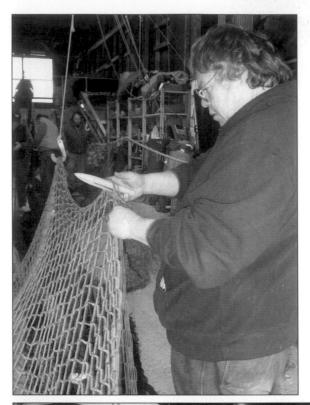

Michael Borovina (left) is captain of the *Sea Pride*. He and his crew (below) mend nets within his net shed at Everett's waterfront. Michael is, quite literally, one of the last fishermen who will ever work on this site as a commercial fisherman. The net sheds are slated for demolition, and a 65-acre development will take their place, leaving Michael and his partners in the industry without a place to store their tools, mend their nets, and continue on with an important legacy. Pictured below in this 2008 photograph are, from left to right, Bob Goetz, Brian Butler, and Ray ?. (Both, courtesy RaeJean Hasenoehrl.)

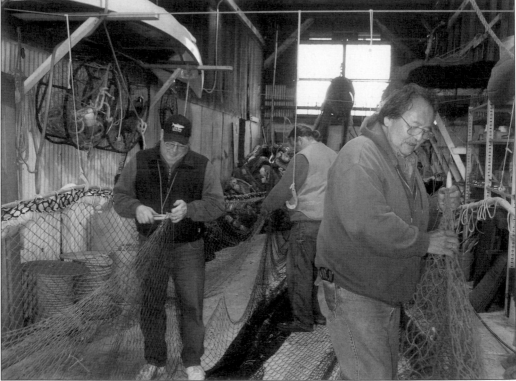

The birth of this book began four years ago when Kay Zuanich learned Everett's net sheds would be destroyed. A 65-acre development would take their place, and nothing would be left to show of Everett's historic fishing industry. Discussion with Barbara Piercey launched a plan to create a memorial to the fishing industry. Port commissioners unanimously approved the plan. Project fund-raising began. In 2007, Kay ran across an Arcadia book and realized a similar book could be created to honor Everett's fishing families and raise funds for the memorial. With help from Cheryl Ann Healey, Katy Brekke, Melissa Holzinger, and RaeJean Hasenoehrl, Kay and Barbara have brought this book to life. Above are Barbara and Kay in front of the net sheds; below, RaeJean, Katy, Cheryl, Kay, Barbara, and Melissa pose with a view of the waterfront behind them. (Both, courtesy Melissa Holzinger.)

ACROSS AMERICA, PEOPLE ARE DISCOVERING
SOMETHING WONDERFUL. THEIR HERITAGE.

Arcadia Publishing is the leading local history publisher in the United States. With more than 4,000 titles in print and hundreds of new titles released every year, Arcadia has extensive specialized experience chronicling the history of communities and celebrating America's hidden stories, bringing to life the people, places, and events from the past. To discover the history of other communities across the nation, please visit:

www.arcadiapublishing.com

Customized search tools allow you to find regional history books about the town where you grew up, the cities where your friends and family live, the town where your parents met, or even that retirement spot you've been dreaming about.